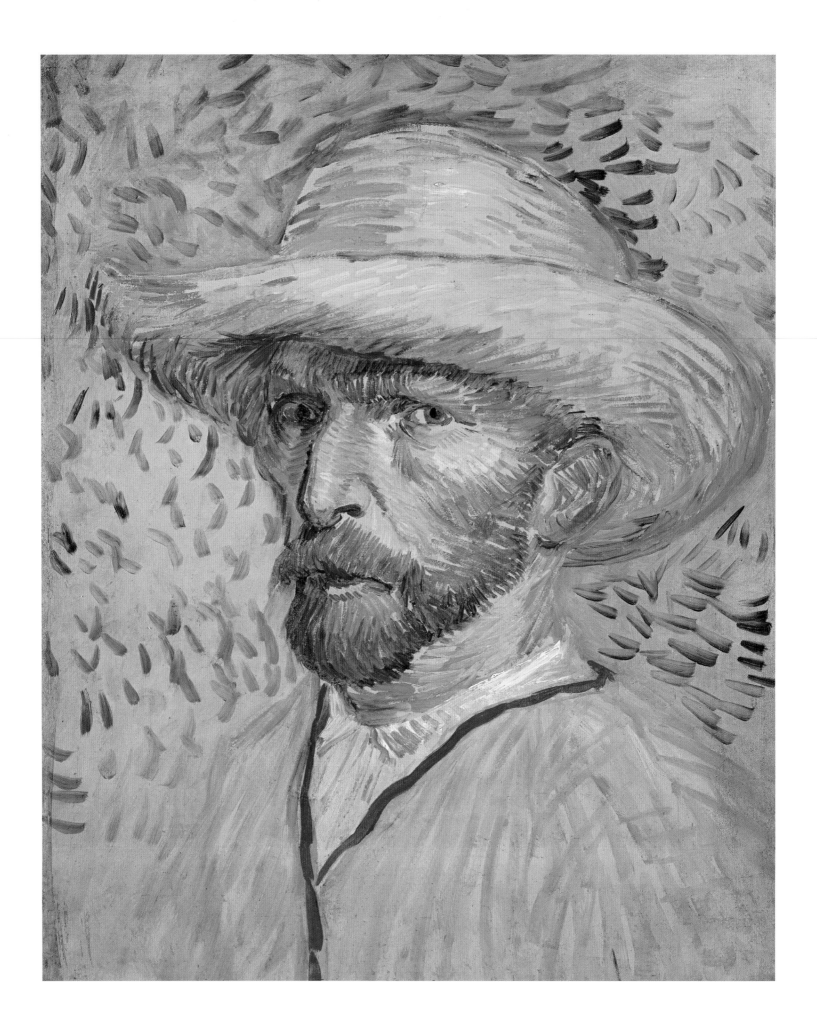

Ingo F. Walther

VINCENT VAN GOGH

1853–1890

Vision and Reality

TASCHEN

ILLUSTRATION P. 2
Self-Portrait with Straw Hat
Paris, summer 1887
Oil on cardboard, 40.5 x 32.5 cm (16 x 12¾ in.)
Van Gogh Museum (Vincent van Gogh Foundation),
Amsterdam

To stay informed about upcoming TASCHEN titles,
please request our magazine at www.taschen.com/magazine,
find our app for iPad on iTunes, or write to TASCHEN America,
6671 Sunset Boulevard, Los Angeles, CA 90028, USA;
contact-us@taschen.com; Fax: +1-323-463-4442.
We will be happy to send you a free copy of our magazine,
which is filled with information about all of our books.

Original edition: © 1986 Benedikt Taschen Verlag GmbH
Editor: Ingo F. Walther, Alling
English translation: Valerie Coyle and Axel Molinski
Cover design: Sense/Net Art Direction,
Andy Disl and Birgit Eichwede, Cologne, www.sense-net.net

Printed in China
ISBN 978-3-8365-3154-2

Contents

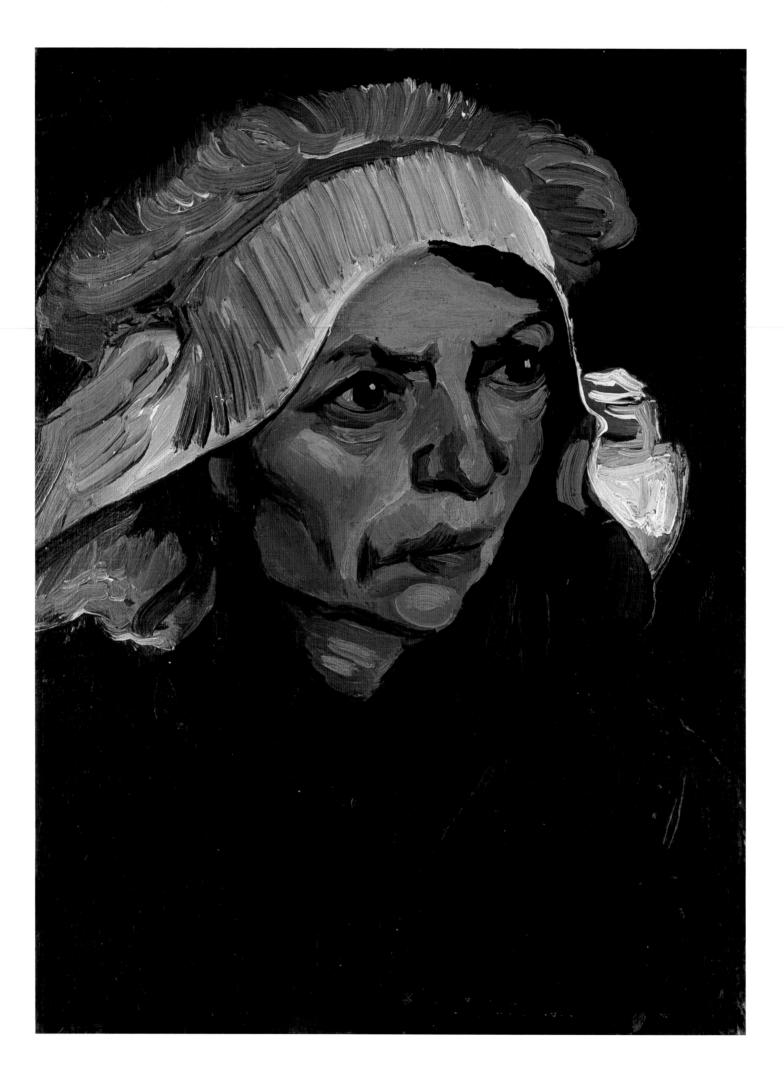

Half Monk, Half Artist
The Beginnings in Holland 1881–1885

Vincent van Gogh was a complete and utter failure in everything that seemed important to his contemporaries. He was not able to start a family, earn his own living, or even keep his friends. Yet in his paintings he was able to set down his own concept of order, against that of the chaos of reality around him. His art was an attempt to regulate a world with which he was obviously unable to come to terms. He countered its unfathomability with the harsh theoretically based criticism of the artist; its anonymity he impressed with his own finely balanced pathos and its run-of-the-mill workings with a solipsistic verve. His aim was not to escape reality, nor indeed to suffer by renouncing it, but instead to make it tangible in a comprehensive sense. In this way his art enabled him to accept the once so hostile world as his own.

His artistic talents were only recognized after his death. The bourgeoisie, whose ideas of value had been so repellent to him all of his life, now used the term "genius" to describe him. The once unloved Vincent now became a hero, the more art presented itself as a world of beautiful appearances. Art had been lodged for hundreds of years on the periphery of society and here van Gogh, himself an outsider, became a personality. He became the embodiment of worldly discontent which overcomes us all now and again. The Modern Age loves to toy with the image of the lonely misunderstood artist. Vincent van Gogh served as a perfect example and he became one of the first martyrs of the avant-garde.

The first son of the Protestant vicar Theodorus van Gogh was stillborn. Exactly one year later to the very day, on 30th March 1853, his wife, Anna Cornelia van Gogh, gave birth to another child. Full of fearful misgiving as to whether the child would survive, she gave it the same name as the first child: Vincent Willem van Gogh. From the moment of his birth, his life was over-shadowed with doubts; Vincent's fundamental experience was and remained that of his foundering. His seemingly promising career as an art dealer, a trade of long-standing in the Netherlands and especially in his own family, ended in his dismissal. His study of theology, begun after this period, proved too much for him and ended a year later.

Following this, van Gogh tried his hand at supply teaching and lay preaching, serving in the Belgian coal-mining area of the Borinage amongst the most poverty-stricken of the poor. Yet the penetrating experience of extreme social misery was not denied him upon the termination of his negligible wage soon after. From this point on on he was completely dependent upon the financial support of his younger brother Theo, four years his junior. He lived with the constant fear of the possible cessation of these funds until his death. Personal

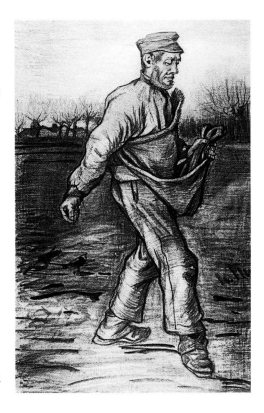

The Sower
The Hague, December 1882
Pen, brush, China ink, 61 x 40 cm (24 x 15¾ in.)
Foundation P. and N. de Boer, Amsterdam

OPPOSITE:
Head of a Peasant Woman with White Cap
Nuenen, March 1885
Oil on canvas on panel, 41 x 31.5 cm (16 x 12½ in.)
Foundation collection E. G. Bührle, Zurich

Head of a Fisherman with Sou'wester
The Hague, January 1883
Black chalk and ink, 43 x 25 cm (17 x 9¾ in.)
Kröller-Müller Museum, Otterlo

happiness was also denied him; his world was not to be graced with the company of women, whom he had tried but failed to woo.

Art became Vincent's only outlet. He turned it into a medium with which he was able to develop experiences, make his comments and articulate his dilemma and hopes. His art was accompanied by an extensive exchange of letters, especially with his brother Theo. In particular Vincent's letters are proof of the way his artistic works increasingly determined his own ideas of reality. They also document the highly theoretical methods with which he set about his work. Letters and paintings establish a paradoxical unit within his work, in which a seemingly naive lack of worldly understanding is accompanied and complemented by a great wealth of reflection.

Van Gogh's decision to become an artist was finalized about 1880. During his employment in the various departments of the Paris art dealer Goupil & Cie, where he had started at the bottom with historical and contemporary works, he was able to articulate his problems by drawing, and this continued during his miserable lay preaching period in the Borinage. After his failure in the various bourgeois professions and his rejection of his theological and social ambitions, he seized upon art, an area which he knew both in theory and in practice. His brother Theo, employed at Goupil's, and his cousin Anton Mauve, himself an artist in The Hague, gave him additional support.

In October 1880 van Gogh moved to Brussels and made friends with the painter Anton van Rappard. In the beginning he produced only drawings, detail sketches and many studies modelled on the works of Jean-François Millet. Millet's somewhat light interpretation of realism provided van Gogh with themes that he could relate to – above all labouring peasants, genre paintings in a dark melancholic tone.

He tried to transmit this mood, which appeared to correspond to his own emotional feelings, into his drawings. Increasingly he began to use unbleached Ingres paper as a base, which enabled him to contrast techniques of painting, blurred contours and flowing transitions of the lines dominating the drawing. The switch to painting was not far away.

On New Year's Day 1882 van Gogh moved into a studio in The Hague, paid for by Theo. Under Mauve's guidance he produced his first oil painting. His early painting of August 1882 *View of the Sea at Scheveningen* (opposite) is strongly influenced by The Hague School to which Mauve belonged. Bound to tradition, The Hague School attempted above all to breathe new life into the landscape paintings of the "Golden Age" of the Dutch Baroque style of painting. Adriaen van de Velde was the Baroque specialist in seascapes and van Gogh related to his combination of landscape with figures busy on the shore.

"When I paint landscapes, there will always be some figure present," he wrote pragmatically. The artistic tradition coincided with his own concept of painting. Nevertheless, this painting contains a tendency towards an autonomization of form and colour. The underlying tendency towards abstraction is evident in the pastose application of colour, in the stressing of parallel layers within the painting and the variety of brownish tones used.

After only one year of practical training, van Gogh's handling of colours counted amongst the best of his time. This can only be explained by his sound training in art appreciation and an equally untiring, almost manic industry. Tone painting still remained an acute problem. Based upon the observations of Eugène Delacroix, the question arose how one could convey pictorially the changes in colour of an object which become apparent at a distance from the object or when it is observed in a different light. The solution finally agreed

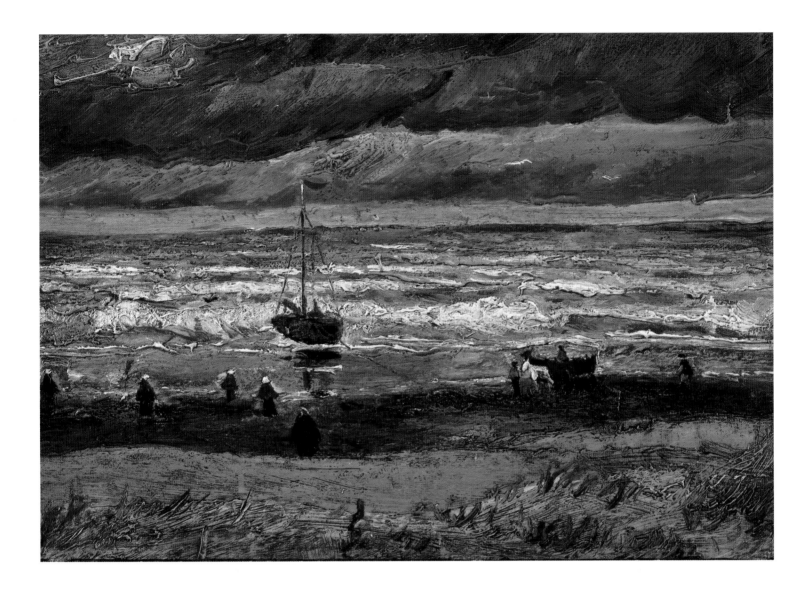

upon was to tone down the actual colour of the object, its natural colour, in order to fit in with that of the dominant monocolour tone of the painting as a whole. No longer was the singularity of the object stressed, but its appearance within the context to which the picture was dedicated. This tendency towards a separation of colour within the painting from the concrete object in reality was the most important step towards a definite autonomy. Colour could now be viewed as a phenomenon, as a pure appearance and a play on well-balanced complementary tones. Van Gogh in his work gave this autonomy an additional dimension, favoured by his own tradition and that of the progressive treatment of colour by Rembrandt or Frans Hals. However, he still moved within the bounds of conventionalism. The tone of van Gogh's works makes pictorial music.

In September 1883 van Gogh left The Hague for the Drente province in north-east Holland, where he lived alone. This move was precipitated by his break from his artistic mentor Mauve. Mauve's criticism of Vincent's relationship with the prostitute Clasina Maria Hoornik could have been a minor reason for this break, in addition to the fact that they no longer saw eye to eye on their views on art. Clasina – known as Sien to Vincent – was both his model and live-in lover. Vincent believed Mauve represented an academic mode of artistic thought adhering to norms, rules and a strict concept of beauty, thereby ignoring the individual expression and the actual social problems which so pre-occupied van Gogh.

View of the Sea at Scheveningen
Scheveningen, August 1882
Oil on paper on cardboard,
34.5 x 51 cm (13½ x 20 in.)
Location unknown. Stolen from the Van Gogh Museum on 7 December 2002

"We have had a lot of wind, storm, and rain here throughout the whole week and I was often in Scheveningen to have a look. I brought two seascapes back home with me. The first one was partly covered with sand – but the second one, made during a heavy storm with the ocean close to the dunes, was covered by a thick coat of sand which I tried to scrape off twice. The storm was so violent that I was hardly able to keep on my feet and the flying sand let me see almost nothing."
VINCENT VAN GOGH

Authority had always been somewhat of a thorn in his side, and Mauve's strict rules may possibly have reminded van Gogh of the bigoted Calvinistic setting of his parents' home. The old love-hate relationship with his origins came to the forefront and van Gogh tried to escape this by withdrawing more and more into himself – into a loneliness which he could not bear. After three months the prodigal son returned home to his parents in Nuenen. By this time the parents had come to terms with their eldest son's artistic career and they even placed a studio at his disposal next to the vicarage.

It was here that van Gogh painted *Loom with Weaver* (p. 13) in May 1884. Sitting before his loom, the weaver is totally immersed in his work. The weaving machine, monumental in size, covers almost the whole of the picture. The over-sized frame envelopes the weaver's slight figure behind a meshed front of horizontal and vertical lines, at times intersecting the figure, making him appear part of the mechanism. Together they stand out as dark silhouettes against a light background, which can never be lit up by the tiny lamp. Every single anecdote, every picturesque element is dispelled in this unifying representation of worker and machine. The harshness and toil as well as the dignity of the worker's life are unmistakably expressed here.

The painting documents, beyond a shadow of a doubt, van Gogh's solidarity and even identification with the depicted worker. Himself a convinced socialist, he knew of the worker's misery from his own experiences and also viewed his art as a form of handiwork. Peasants, weavers and coal-miners became the preferred subject matter of his early works. They were representatives of the rural proletariat, not town dwellers, although van Gogh was familiar with urban populations

The Poor and Money
The Hague, September 1882
Watercolour, 38 x 57 cm (15 x 22½ in.)
Van Gogh Museum (Vincent van Gogh Foundation), Amsterdam

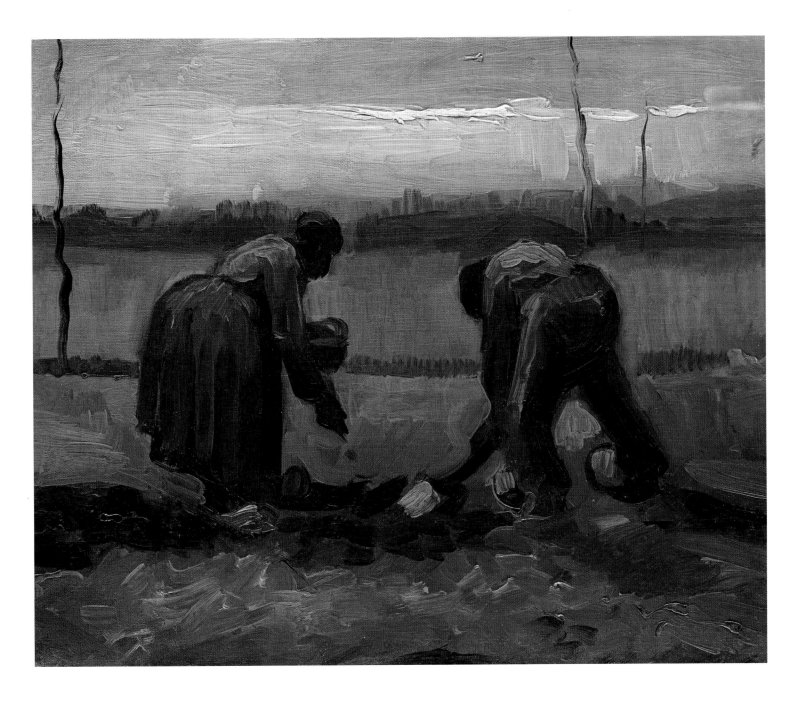

Peasant and Peasant Woman Planting Potatoes
Nuenen, April 1885
Oil on canvas, 33 x 41 cm (13 x 16 in.)
Kunsthaus Zürich, Zurich

Weaver
Nuenen, February–March 1884
Pen and ink, 26 x 21 cm (10¼ x 8¼ in.)
Van Gogh Museum (Vincent van Gogh
Foundation), Amsterdam

"If you ask me what I am working on at the moment I can tell you that I have my hands full with a large picture showing a weaver – the loom in the very foreground, the figure as a dark silhouette against a white wall ... I'll have no end of trouble with these looms, but they present such a wonderful challenge – the old oakwood against a greyish wall – and I am quite sure that they are worth being painted."

VINCENT VAN GOGH

from stays in both London and Paris. This choice underlined his deeply rooted aversion to industrialization, specifically to a world of technology in which man was nothing more than a mere machine. Van Gogh backed a strange pessimistic view of progress, shared by the English social utopians William Morris and John Ruskin. The ideal of a ruler-free society was here combined with the praise of manual work. The self-sufficient worker, amongst whom van Gogh counted himself, was his central socialist concern. In this he also distinguished himself from the then popular Naturalists, whose exponents, the most important being the author Emile Zola, believed in depicting the misery of the worker neutrally, rather than actively sharing in this misery. The ennoblement of the worker, which became a theme of Naturalist art, was not enough for van Gogh. The worker ought also to be the consumer of his works. Art of the people for the people was the social impetus of his works. Paintings such as *The Poor and Money* (p. 10) and *Peasant and Peasant Woman Planting Potatoes* (p. 11) exemplify this priniple. Anonymous peasants or workers are central figures of these works, as worthy of being depicted as the most glorious heroes from history and mythology.

Once, on one occasion only, van Gogh's peasants were both theme and consumer of the work. With his brother's help he was able to have twenty lithographs of his *The Potato Eaters* printed, which people from his neighbourhood could buy at a reasonable price. In many respects this picture (p. 14) of April 1885 is representative of his early work as a whole. Solidarity and poverty are revealed in the sparse meal, which the five emaciated, hard-working figures have to share. Potatoes and malt coffee are passed around the table, and the unselfish communal feeling reaches an almost religious, tranquil pathos.

"Indeed I have tried very hard," Vincent wrote to his brother Theo, "to convey to the observer the idea that these people, who are eating potatoes by lamplight, reaching into the bowl with their hands, use the same hands to till the soil. The painting therefore conveys the idea of their manual work and as a consequence of this that their meal has been honestly earned ... But those who would rather see the peasant in an ideal light can stick to their views." An inner strength appears to radiate from their faces, increasing their dignity even more. The light effect is gained by the sparse use of yellow as a contrast to the dark, brown-toned background. The painting came about after careful planning and a lot of preparatory studies, to which the *Head of a Peasant Woman with White Cap* (p. 6) of March 1885 also belongs. The lack of communication between the five figures, whose eyes appear hardly ever to meet, can perhaps be explained by the compilation of several different studies into one whole picture. Still the putative lack in the composition confers a stillness and quiet melancholy on the painting.

"You'll no doubt agree with me that such a piece of work is not to be taken seriously. Thank goodness you are capable of more than this." This critical comment of Rappard's towards his sensitive friend's painting marked the end of their friendship. Due to his academic training Rappard concentrated on the apparent "mistakes" in *The Potato Eaters*, such as the too-short arms, emaciated faces and miscalculated proportions. Yet it was precisely these points which marked out van Gogh's own view of beauty, based on the people in his environment, who were admittedly not beautiful, but who embodied his idea of truth.

Van Gogh's aesthetics were created because of his aversion to the traditional norms, his solidarity with the poor and also perhaps a genuine lack of artistic technique. He managed to pull himself together, to identify with his artistic being and to fill in those missing parts of his artistic technique by hard work and

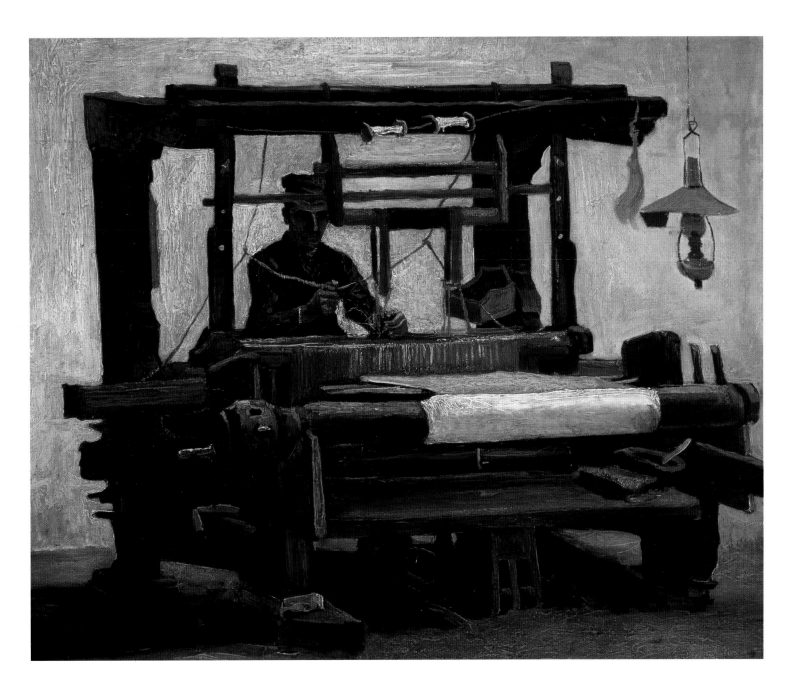

Loom with Weaver
Nuenen, May 1884
Oil on canvas, 70 x 85 cm (27½ x 33½ in.)
Kröller-Müller Museum, Otterlo

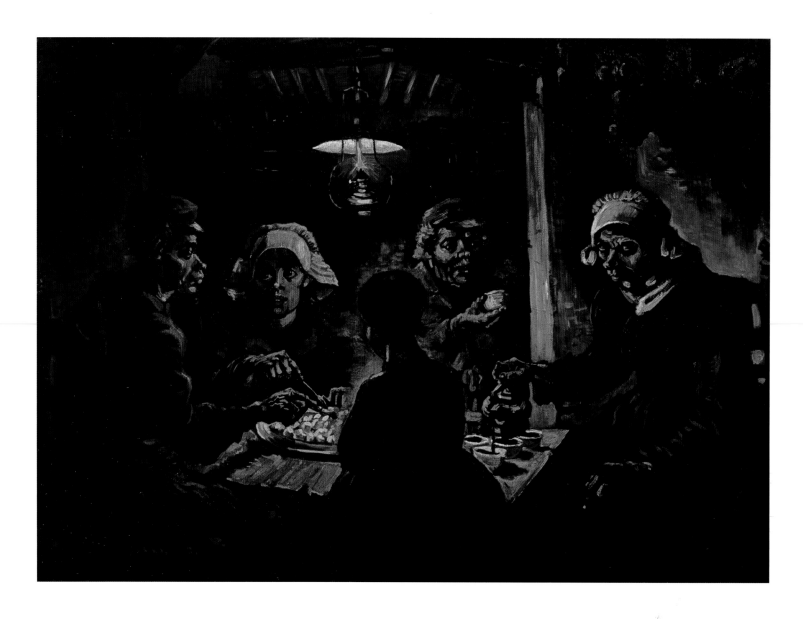

The Potato Eaters
Nuenen, April 1885
Oil on canvas, 82 x 114 cm (32¼ x 45 in.)
Van Gogh Museum (Vincent van Gogh
Foundation), Amsterdam

"Amongst this confusion I was dismayed by a
meal poor people had in a weird hut under a dim
lamp. He called it 'The Potato Eaters'. It was ugly
in a splendid way and loaded with an alarming
activity."

EMILE BERNARD

continual practice. Art was then an individual medium of expression; beauty
and ugliness were criteria of the individual and not categories of a general con-
vention. Van Gogh's aesthetics of ugliness, already outlined in the 18th-century
theoretical works of Edmund Burke and Denis Diderot, are characteristic of his
works: deformation and gaudy colours vouch for his special quality of artistic
creativity. His pictorial language always remains based on concrete reality and is
a reaction to it, as well as being a personal commentary on it – indeed, personal
in such a way that the established rules would destroy it.

On 26th March 1885 his father, Theodorus van Gogh, died. From now on
Vincent's life in the village of Nuenen became more difficult. The locals were
afraid of his unpredictable behaviour. He had always loved these people, felt a
part of them, but still he was unable to explain himself to them. His departure
to Antwerp meant a change not only in his personal circumstances but also a
thematic change in his work. The preoccupation with social problems which was
so obviously depicted in his earlier paintings was now overtaken by a purely
artistic debate: Van Gogh's subject matter was to change. However, he remained
faithful in his fight to assert his own ideas and his emotional protests against the
formulaic.

Still Life with Bible (opposite) painted in October 1885, shortly before his
departure, laid his past to rest without further ado. The Bible, a symbol of his
parents' home and religious upbringing, has a rival in the painting – Zola's

La Joie de vivre, a cult book of the Naturalist movement and considered by the old Theodorus as one of the most despicable works of the devil. The candle, an instrument of sacred rites, raises both books to the same level, and grants each of them the same meaning. Yet the candle has been blown out.

In the cosmopolitan city of Paris, van Gogh distanced himself from both books. Christianity and socialism were joined together to form a new religion, but not one that ruled his life. The new, exclusive religion was art.

"But I have to keep on going my own way. If I don't do anything, if I don't study, if I don't search – then I am lost. Then God help me!"
VINCENT VAN GOGH

Still Life with Bible
Nuenen, October 1885
Oil on canvas, 65.7 x 78.5 cm (26 x 40 in.)
Van Gogh Museum (Vincent van Gogh Foundation), Amsterdam

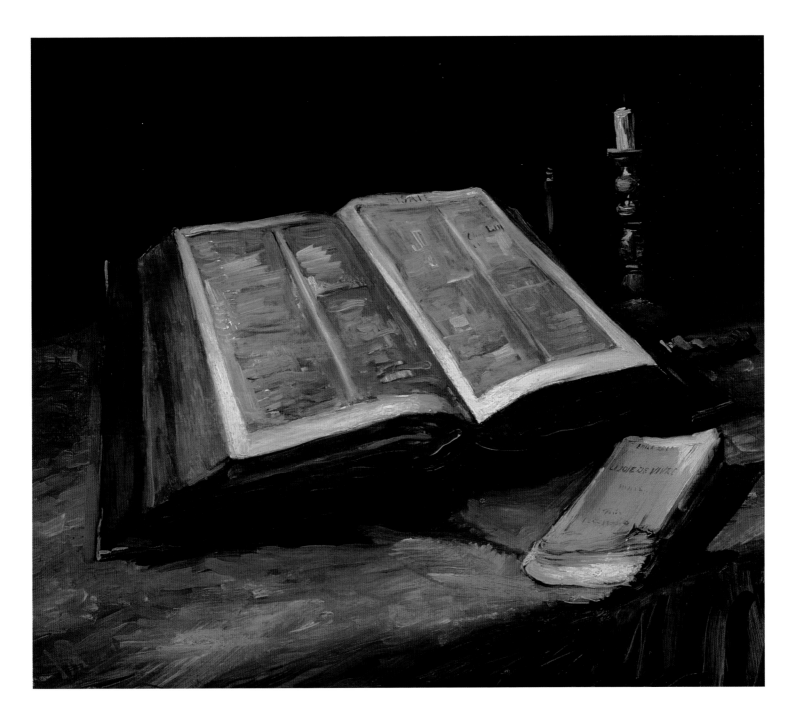

Apprenticeship Years in Paris
Antwerp and Paris 1885–1888

At the end of November 1885 van Gogh arrived in Antwerp, then a large and important harbour, carrying only one suitcase containing *The Potato Eaters*. Here he stayed for a short time before going on to Paris, the capital city of the 19th century. However, this stay proved to be of great importance to his later work as it was in Antwerp that he began to experiment properly with all sorts of techniques. He was able to break away from the Calvinistic rigorousness yet still secure environment of his home, and in so doing set free his creative energy. Vincent abandoned his earlier depiction of the gloomy, depressive world of the peasants for a period of experimentation, over the next two years, with everything that was artistically unusual, progressive, and avant-garde.

Van Gogh settled himself as best as possible into a small attic, paid for with Theo's help. He bought Japanese woodcuts at a bargain price from the antique dealers along the harbour-front and decorated the bare walls of his rooms with them. In this way he got his first taste of their decorative colourfulness, which was to make a lasting impression to him. At the Royal Academy he practised making plaster copies of classical sculptures. Yet even here, just as in The Hague, the dogma of classical beauty repelled him. This dogma reduced the individuality of art to a mere mechanical copying. His acquaintance with Peter Paul Rubens, the old master of the Baroque, became more important to him. Rubens also had a studio in Antwerp. The gaiety of the colours, the rounded forms and ample volumes, marked out the Baroque painter of Catholic origin as a necessary alternative to the reserved, controlled severity of the Dutch School of Art.

One morning, at the beginning of March 1886, Theo received a message: "From lunchtime on I will be in the Louvre, or even earlier if you want." Vincent had hinted again and again in his letters from Antwerp of his plans to move to Paris, but this completely took his brother by surprise. Now he had actually arrived in Paris and was planning to move in with his brother. Theo reluctantly agreed. For the following two years there were to be continual disputes over Vincent's various escapades, followed by Theo's apologies.

Still Life with Mackerels, Lemons and Tomatoes (p. 18), one of his earlier Paris paintings, was done in the summer of 1886. The innovative technique, learned in Antwerp, can be clearly seen here. The loud red of the tomatoes contrasts effectively with the green of the jug, in fact the use of pure colours as a whole, which do not merge with the background colours of the paintings, points directly to Rubens' influence. The inexplicable nature of the interrelationship of space, the blurred borders between table, tomatoes and jug, one behind the other, point towards the influence of Japanese prints, in which the spatial continuum is at odds with the ornamental surface.

"I prefer to have one hundred francs a month and the freedom to spend it just as I like than to have two hundred francs without this freedom."
VINCENT VAN GOGH

OPPOSITE:
Montmartre
Paris, autumn 1886
Canvas on panel, 43.6 x 33 cm (17¼ x 13 in.)
The Art Institute of Chicago, Chicago

Henri de Toulouse-Lautrec and Emile Bernard were perhaps the most talented and by far the most famous graduates of the Cormon studio. The painter Fernand Cormon, on the one hand a fairly unknown artist, was on the other hand a relatviively successful teacher and the owner of this art school. For three months van Gogh was to study at the studio and while there he distanced himself from his earlier genre pictures of peasants and workers.

It was here that he made friends with Toulouse-Lautrec and Bernard. Through Theo, who managed a small branch of Goupil's, where he informally set up exhibitions of Impressionist paintings on the mezzanine floor, Vincent got to know Paul Gauguin, himself then an equally unknown artist, and Camille Pissarro, the then sixty-year-old great man of Impressionism. He looked upon these men as his friends and together they frequented the neighbouring small cafés and cheap restaurants of their living quarters, the Boulevard de Clichy in Montmartre. He dreamed of forming a great artist commune with them, where everyone worked with and for one another – a dream which sadly would never be realized.

In *Montmartre* (p. 16), a painting of October–December 1886, van Gogh portrays a grey wintry scene in a hazy fog. The frosty atmosphere of the approaching winter is exactly that of the Impressionists' atmospheric paintings. Also the neutrality of the whole, with its seemingly detached passers-by hurrying along the street and the fragmentary optical effect of the painting with its

Still Life with Mackerels, Lemons and Tomatoes (formerly attributed)
Paris, summer 1886
Oil on canvas, 37.5 x 55 cm (14¾ x 21½ in.)
Oskar Reinhart collection "Am Römerholz", Winterthur

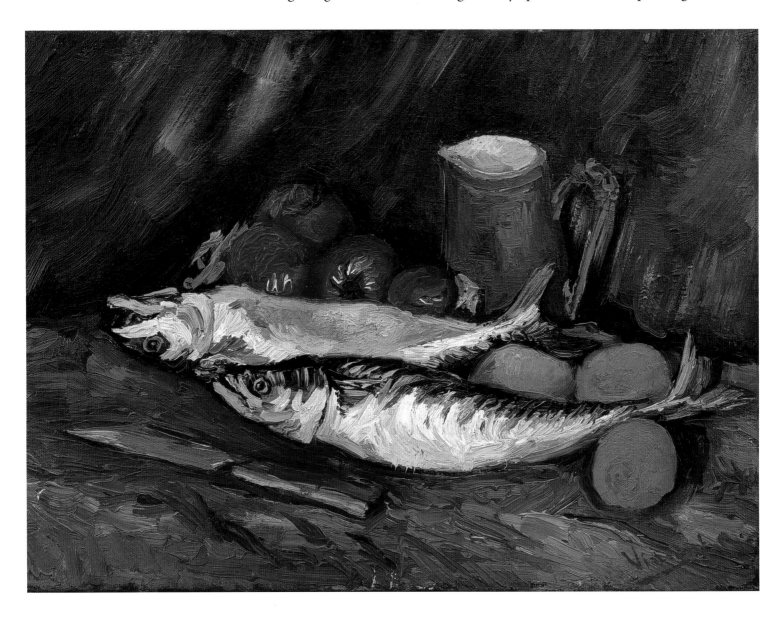

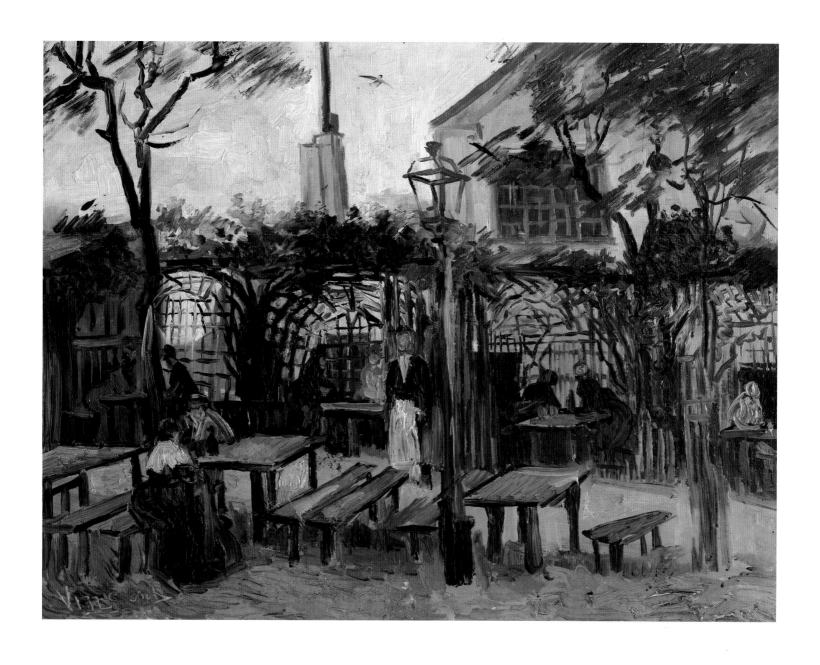

Terrace of a Café on Montmartre (La Guinguette)
Paris, October 1886
Oil on canvas, 49 x 64 cm (19¼ x 25¼ in.)
Musée d'Orsay, Paris

intersecting area of view, belongs to the tradition of Claude Monet or Auguste Renoir.

In October 1886 van Gogh painted *Terrace of a Café on Montmartre (La Guinguette)* (p.19). Here again he based his work on a typical Impressionist interpretation. The soft red of the autumnal-coloured leaves, the half-empty seats in the foreground, the view into the alcoves – portrayed with a few strokes of the brush – crystallize a quiet everyday scene, a momentary observation without any deep meaning. The sporadic application of pastose colour does not change this, nor does the concealed placing of local colour, which comes out in the autumnal ochre. In these paintings van Gogh is experimenting with Impressionist techniques.

When Vincent arrived in Paris in 1886, Impressionism had already become a thing of the past. Edouard Manet, the progenitor of the movement, was dead and at their eighth exhibition, which took place that very year, Neo-Impressionism made its appearance in the form of Georges Seurat's famous *A Summer Afternoon on the Ile Grande Jatte* (Chicago, Art Institute). The apparent indifference of the Impressionist style, the rejection of any form of personal expression, the near mechanical transposition of observations into a spontaneous ad hoc painting – all this was criticized not only by traditionalists but also by a confident, self-designated brilliant young generation. Light was the watch word of the Impressionists, light as the medium of all appearances, as a basic element connecting all things and as a life-giving force. Yet the philosophical background admittedly fell short of the mark. No artist painting during this period could avoid the Impressionist movement. What was left to van Gogh and the other rebellious young artists was the revelling in brightness, the use of a pure white, as well as the inclusion of detail and apparently incoherent spatial structure.

"I'd rather paint peoples' eyes than cathedrals." With these words van Gogh commented on the thematic preference of the Impressionists, appearing to refer to Monet's Rouen cathedrals, a series of paintings depicting this cathedral from various positions at different times of the day. Van Gogh preferred to paint portraits. *In the Café: Agostina Segatori in Le Tambourin* of February 1887 (opposite) is not a mere depiction of an anonymous neglected drunk in any old dive, but a concrete portrait. The Italian Agostina Segatori, the former model of, amongst others, Camille Corot and Edgar Degas, and also the owner of the café, is portrayed sitting at a table. Vincent had a short affair with her and she often sat as a model for him, sometimes nude. The table and chairs in his painting had the same percussion-like shape as those in the café itself. In general, the exotic charm of the painting, the woman's unusual hairstyle and her folkloric dress, as well as the fan on the chair and the famous Japanese woodcuts in the background, are much more central to an understanding of the painting than the smoky milieu of the dive, which so fascinated Degas in his *Absinthe Drinker* (Musée d'Orsay, Paris) – an obvious model for van Gogh's painting. The woman's large melancholy eyes, in contrast to the strange surroundings, endow the painting with a special, carefully considered atmosphere which is the opposite of that usually depicted by the Impressionists.

Van Gogh ironically called the clique of artists with whom he lived, worked and exhibited on Montmartre "Peintres du Petit Boulevard". All of them lived simply, having established themselves in the seclusion of the large boulevards, and they countered their lack of publicity with a love of experimentation. In a restaurant, Du Chalet, on the Boulevard de Clichy, van Gogh, Toulouse-Lautrec, Bernard and Louis Anquetin had their first exhibition in 1887.

OPPOSITE:
In the Café: Agostina Segatori in Le Tambourin
Paris, February–March 1887
Oil on canvas, 55.5 x 46.5 cm (21¾ x 18¼ in.)
Van Gogh Museum (Vincent van Gogh Foundation), Amsterdam

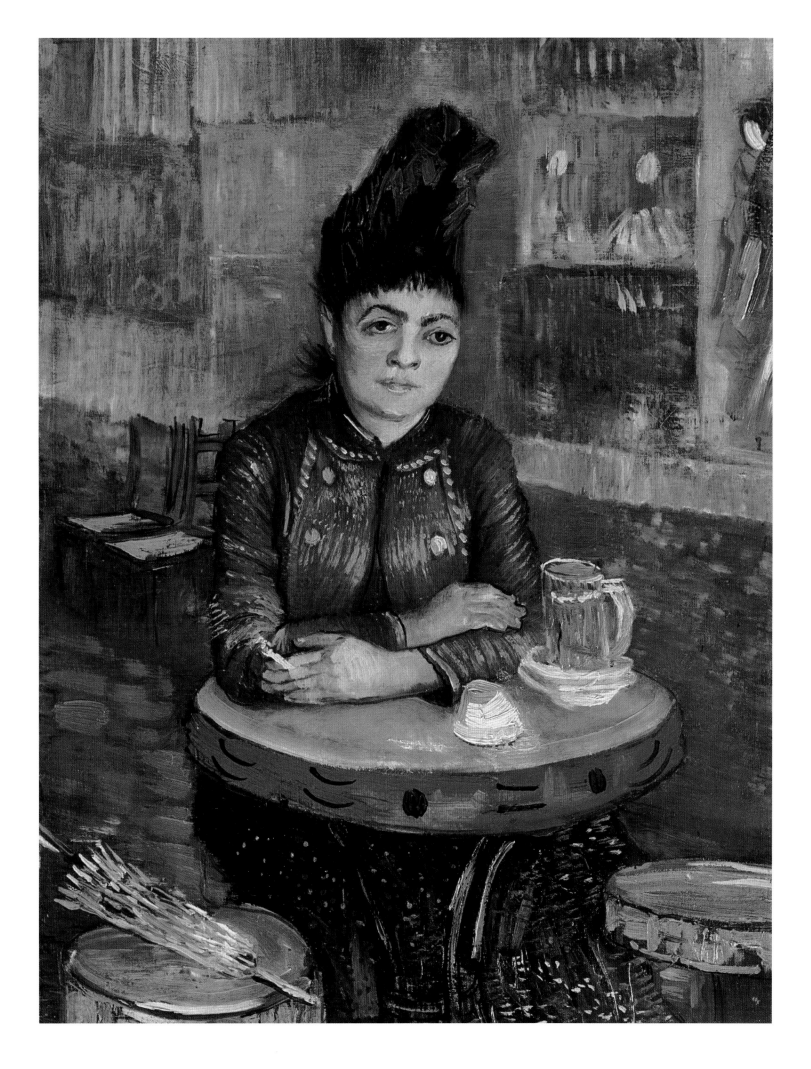

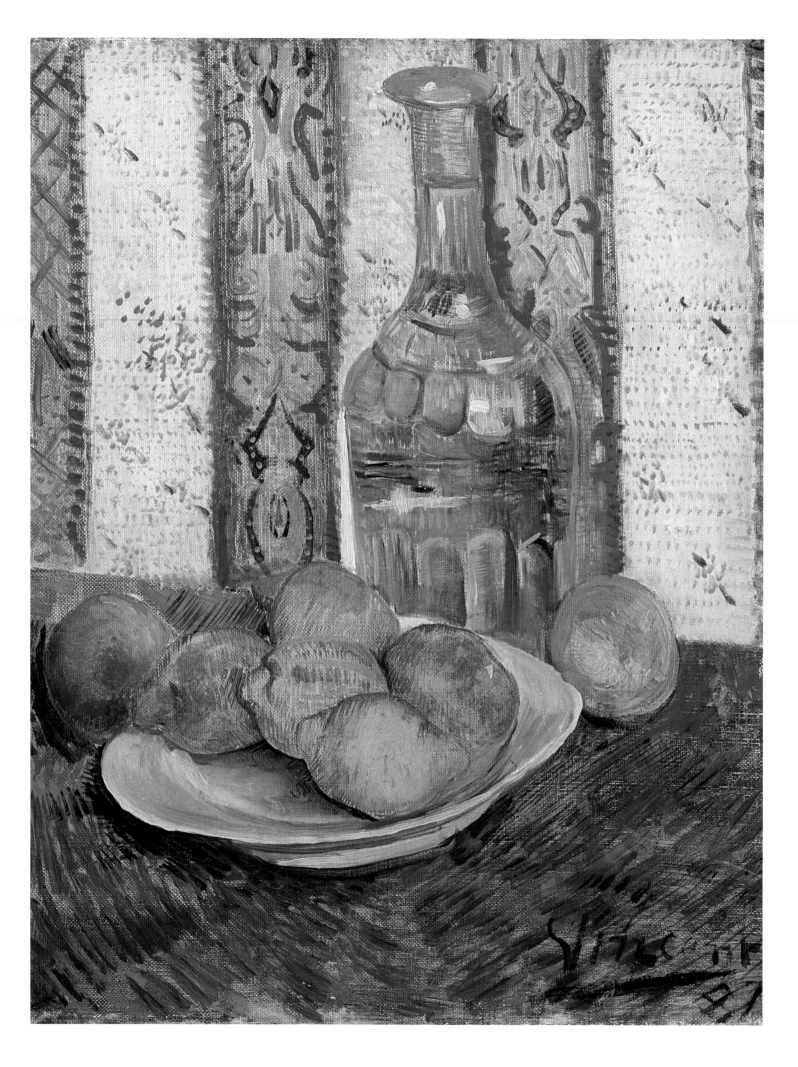

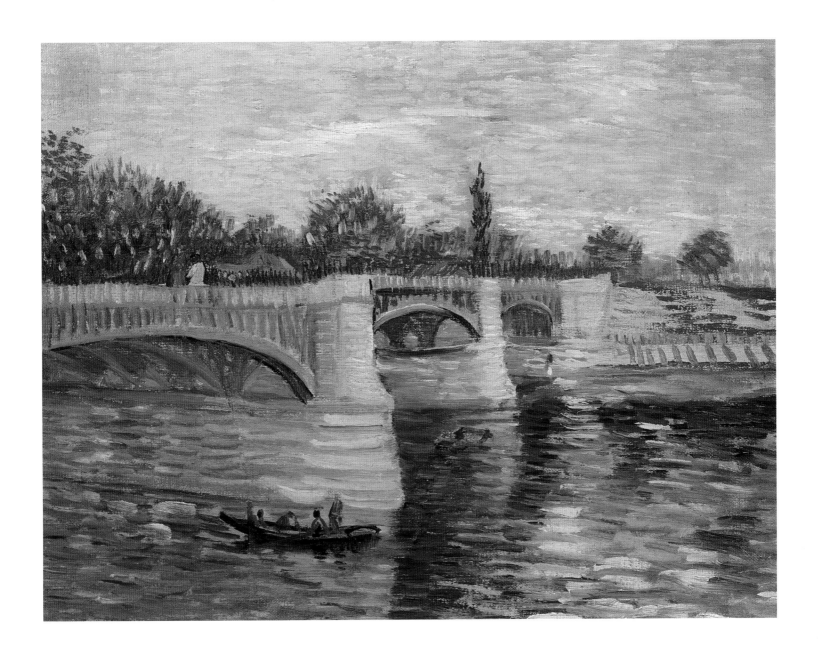

The Seine with the Pont de la Grande Jatte
Paris, summer 1887
Oil on canvas, 32 x 40.5 cm (12½ x 16 in.)
Van Gogh Museum (Vincent van Gogh Foundation), Amsterdam

OPPOSITE:
Still Life with Carafe and Lemons
Paris, spring 1887
Oil on canvas, 46.5 x 38.5 cm (18¼ x 15 in.)
Van Gogh Museum (Vincent van Gogh Foundation), Amsterdam

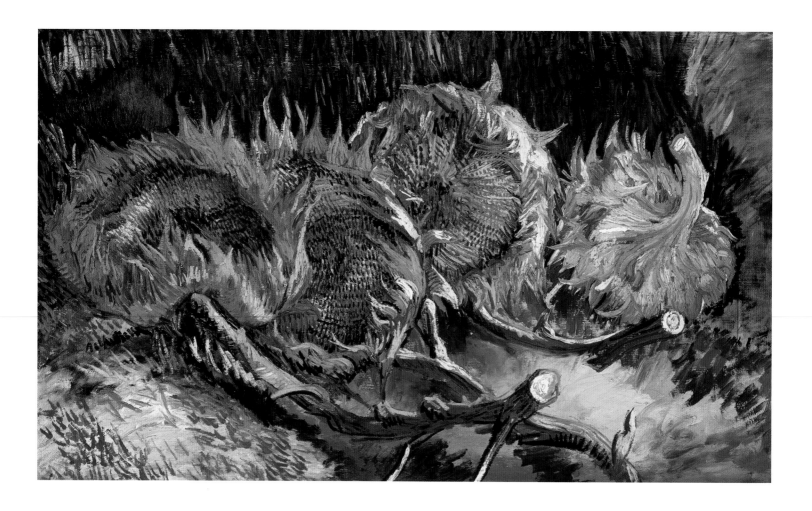

Four Sunflowers Gone to Seed
Paris, August–October 1887
Oil on canvas, 60 x 100 cm (23½ x 39½ in.)
Kröller-Müller Museum, Otterlo

Nothing was sold, but the exhibition was followed by long discussions and to round it all off in a congenial manner they exchanged one another's works. Their impoverished artistic idyll, with its Bohemian chic, was precisely what united artists of all nationalities in Paris. They lived, convinced of their own genius, in the absolute assurance that they would one day soon revolutionize the art world.

They could only afford to go on trips in the area around Paris. Together with Gauguin and Bernard, van Gogh spent many days in Asnières, a popular spa town on the Seine. It was here that he painted *The Seine with the Pont de la Grande Jatte* (p. 23) in summer 1887. The bridge cuts diagonally across the painting. It was an often-repeated Impressionist motif, simply overlapping the frame, thereby expressing the momentary nature of the painting. Van Gogh obviously drew upon this symbolism in his painting. At first sight the application of colour appears somewhat confused in its horizontal, vertical and diagonal strokes and the complete abandonment of colour surfaces with a simultaneous stress on the intensity of colour, attempts to overcome by the same means the radiant atmospheric feeling in favour of the timeless self-control, as in contemporary Pointillist works.

The incunabulum of this style of painting is Seurat's *Sunday Afternoon on the Ile Grande Jatte*, which van Gogh cites as a subject of his painting. Seurat and his friends, above all Paul Signac, wanted to place Impressionism on a quasi-scientific level. Filled to the brim with theories concerning colour changes, voluminous effects and the psychology of perception, they attempted to distill objective rules out of the style of Impressionism, above all to gear their paintings towards the same objective representation as they preached in their theoretical dogma. Van Gogh, a good friend of Signac, looked upon this scientific ordering of art as exaggerated. However, the methods of breaking up colours into small

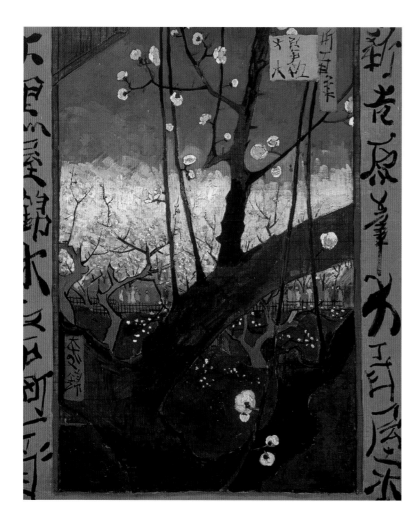

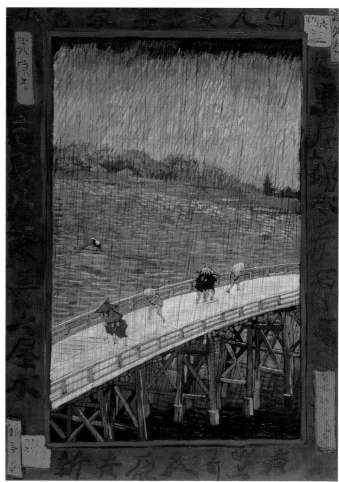

dots, which only became effective when one looked at them from a distance and could then view the continuous movement in the area, correspond to his own love of experimentation. Even in his depressing paintings of later years this particular splitting of colour has a validity. *Flowers in a Blue Vase* (p. 26) of June 1887 shows van Gogh's fascination with every last stroke and dot of colour, particularly in the shimmering background, in front of which the voluptuous brightness of the flowers is moderated.

That he also had other forms of artistic expression at his disposal can be seen from the painting *Four Sunflowers Gone to Seed* (opposite) of the same period. The four withering flowers, viewed from up close, hang on shrivelled stems which have been cut a long time ago. They spread out their short petals in front, like licking flames, as if to revolt against the threatening decay, already anticipating the ecstatic blazing vitality of van Gogh's later cypress paintings. In this painting Vincent was able to endow the banal commonplace subject with an almost existential meaningfulness, and objects are given a symbolic significance, ciphers of some form of suffering, which one has to look for first of all in the artist himself.

This vitalizing view of things is first and foremost a reaction against photography: "One strives for a more profound similarity than photography," the painter wrote to his sister. Yet still more important is the decorative, symbolizing, immediate effect, which the painting's appearance, stripped of all the motifs taken from reality, conjures up. This effect, which has nothing to do with the cultivated refinement of Impressionism, but which demands instead spontaneous sympathy, even consternation – all this is powerfully incited by a simple sunflower.

LEFT:
Flowering Plum Tree (after Hiroshige)
Paris, September–October 1887
Oil on canvas, 55 x 46 cm (21½ x 18 in.)
Van Gogh Museum (Vincent van Gogh Foundation), Amsterdam

RIGHT:
The Bridge in the Rain (after Hiroshige)
Paris, September–October 1887
Oil on canvas, 73 x 54 cm (28¾ x 21¼ in.)
Van Gogh Museum (Vincent van Gogh Foundation), Amsterdam

"I envy the Japanese artists for the incredible neat clarity which all their works have. It is never boring and you never get the impression that they work in a hurry. It is as simple as breathing; they draw a figure with a couple of strokes with such an unfailing easiness as if it were as easy as buttoning one's waist-coat."

VINCENT VAN GOGH

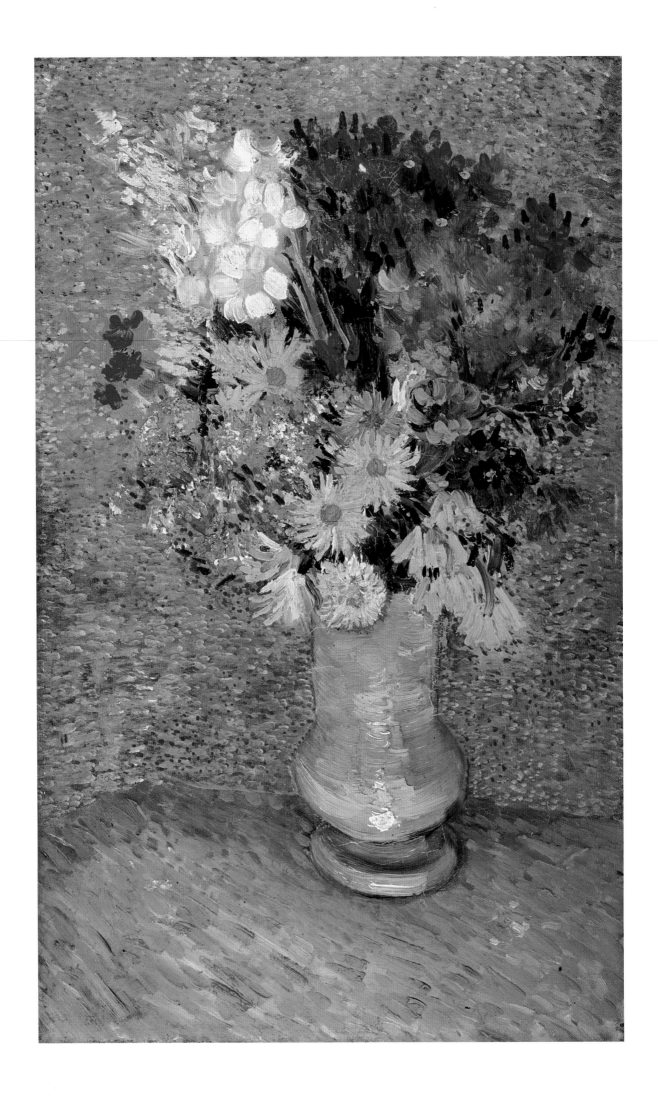

This effect is guaranteed above all by the complementary contrast between the dirty yellow and the shimmering blue of the diffuse background. For a long time van Gogh had studied the colour theories of Delacroix. The most important finding for van Gogh – thoughts on colour autonomy aside – was the deployment of complementary contrasts. These can be achieved by contrasting one of the three primary colours – yellow, red, blue – with a mixture of the other two. The combinations red–green, yellow–violet, blue–orange are able to increase one another's intensity of colour or neutralize themselves to a dull grey when mixed. This seemingly ordinary trick can in fact often create an extraordinary effect.

Van Gogh wanted to learn everything at once during his time in Paris. It was as if he wanted to experiment with all the multi-faceted means of expression the melting-pot Paris offered in his only medium, painting. This experimentation was not merely restricted to art. The multifarious means of expression determine his *Still Life with Carafe and Lemons* (p. 22) of spring 1887. The hard, solid shape of the fruit is surrounded by a fine sketchy background consisting of radial lines which take up the plate's contour. The reddish-yellow of the fruit and the greeny-blue of the background present a complementary contrast. In keeping with the spirit of Impressionism, colour and light are refracted in the transparent lightness of the fluted bottle. In the background one can recognize the lineal patterning, which points to a further important field of artistic expression which van Gogh seized upon during this period – that of Japanese art, which was then a widely spread trend in artistic circles.

The Japanese stand caused a lot of excitement at the World Exhibition in Paris in 1867. Visitors, with their cosmopolitan attitudes, admired the exotic strangeness, which clearly indicated a high degree of civilized cultural development in the Far East. Suddenly, in the better circles of society, women began using fans, wearing kimonos and having China crockery and screens in their bourgeois homes. The large stores all opened a Japanese department. In this way a new fashion craze was born. The reaction to this trend in the art world was not long in coming. Woodcuts from Japan, either cheap copies or expensive imports, suddenly became stylish. A suitable answer to the Impressionists' abandonment of form was found in the use of solid contours, and the decorative colours could be seen as a reaction against the *triste* representation of misery by the Naturalists.

The art of copying Japanese woodcuts is called Japonaiserie. Van Gogh is known to have made three such copies – his *The Bridge in the Rain (after Hiroshige)* and his *Flowering Plum Tree (after Hiroshige)* (both p. 25) are based upon Hiroshige, one of the last famous masters and virtually a contemporary of van Gogh. Nineteenth-century Japanese woodcuts display similarities with Western art and this very fact favoured their adoption. In all his attempts at imitating this art form, van Gogh's versions proved to be worlds apart from the originals. He never attained the smooth application of colour as in Hiroshige's work – the opposite, in fact. His pastose use of colour emphasizes his personal touch, rather than remaining anonymous. He even changed the format of the picture by widening the small frame with lines of Japanese characters, whose meaning he was certain not to know. In short, van Gogh Europeanized the source material, and in so doing brought it into line with his own artistic concept so that it corresponded to the actual trend.

By the end of his stay in Paris, Vincent had painted three portraits of the old art dealer Julien Tanguy, known to everybody as Père Tanguy. Père had lived through the great era of the realization of socialist ideals, the days of the Paris

"He is a painter, he will remain a painter; whether he, still young, translates Holland into the dark, whether he, a little bit older, paints Montmartre and its gardens as a Divisionist, or whether he paints the south or Auvers-sur-Oise with a furious pastose application of colour. Whether he draws or not, whether he loses himself in colour spots or deformations, he will remain a painter for ever and ever."

EMILE BERNARD

OPPOSITE:
Flowers in a Blue Vase
Paris, June 1887
Oil on canvas, 61 x 38 cm (24 x 15 in.)
Kröller-Müller Museum, Otterlo

Portrait of Père Tanguy
Paris, winter 1887–88
Pencil, 21.5 x 13.5 cm (8.5 x 5¼ in.)
Van Gogh Museum (Vincent van Gogh
Foundation), Amsterdam

Commune, and because of this he was forced to go into exile. The artists looked upon him as the grand seigneur of their own utopian ideals. They bought all of their material cheaply from Tanguy, often on credit. He even had a small gallery in a side room, but this was ignored by the general public. Père Tanguy can be seen as a key figure in the Modernist movement, since it was in this small gallery that artists such as van Gogh, Seurat, Gauguin and Paul Cézanne, who were later considered to be the precursors of the 20th century, exhibited their works. In no other place could they get to know one another's works so well. It was Cézanne who called van Gogh's paintings the "works of a lunatic".

The *Portrait of Père Tanguy* (opposite) is the epitome of van Gogh's work in Paris, as *The Potato Eaters* was for his earlier stay in Holland. Resolutely facing forwards, almost symmetrical, monumental in his stance, he dominates the foreground of the picture. This simplified portrayal contrasts with the complicated background structure, decorated with Japanese woodcuts. The whole picture appears extremely flat and the Japanese dancers appear to push against the figure in the front of the painting. The levelling out of the spatial interrelationship is evident here, abandoning the illusion of concrete reality.

Van Gogh was to further extend this principle, which opened up the way for him to depict other realities freely – that is, his own inner world, which had so often already vehemently asserted itself. Colour and command of the brush were to become his decisive means of expression. The lightness of Impressionism, the dissolution of areas into graphic structures using the technique of Pointillism, the decorative flatness of Japonaiserie – all of these principles van Gogh had acquired during his two years in Paris, through continual debate with his fellow artists. He had discussed Delacroix' colour theories with them and perfected the use of complementary contrasts, the rigid use of the colour black and also the increasing abandonment of local colour. These theories became second nature to him; composition and use of colour no longer needed any great consideration – they appeared as spontaneous gestures on the canvas. Van Gogh's time in Paris was his most educational and here he dismissed the academic mode of art. The more art became his sole preoccupation in life, the more he gained understanding through contact with other artists.

So he was ready to follow that path which Cézanne had already trodden. He wanted to go south, where nature, which was so central to his studies, was friendlier, the light brighter and the colours more intense. A rift with his brother, who had got into trouble with his employers because of Vincent's escapades, was imminent. Full of hopes, Vincent van Gogh boarded the train to Arles on 20th February 1888.

OPPOSITE:
Portrait of Père Tanguy
Paris, winter 1887–88
Oil on canvas, 65 x 51 cm (25.5 x 20 in.)
Athens, Collection Niarchos

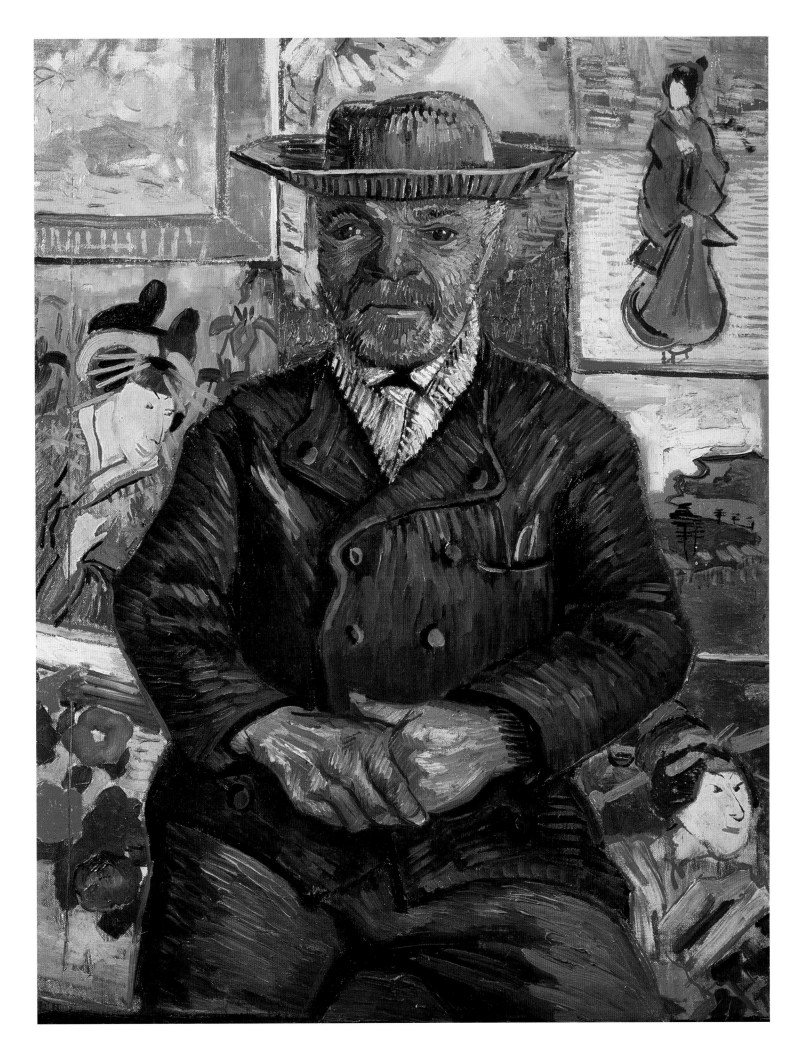

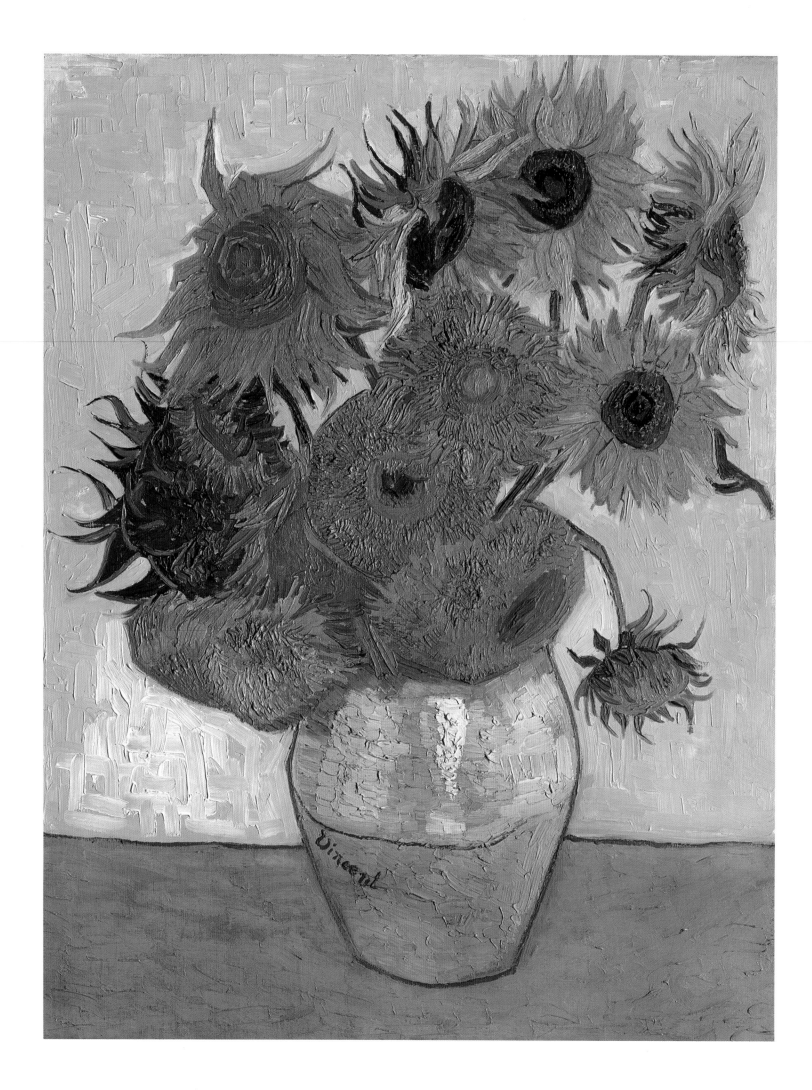

The Explosion of Colour
Arles 1888–1889

Ever since Albert Dürer's Italian travels, artists from the north of Europe had been drawn in their droves to the Mediterranean, pulled by the fascination of the south. It was not only the architecture and painting of the Quattrocento, nor the elevated feeling gained from actually walking on ground saturated with centuries of history, but also the fascination which the Mediterranean landscapes held for northern artists, with their mild climate and warm sun bathing the landscape in radiant light.

The consequences of this "artists' pilgrimage" can be seen in the paintings themselves: the palettes became more colourful, the colours brighter and the themes recalled the classical age. Paul Klee summed up the experience gained from such a stay in the south in his emphatic declaration after he returned from his Tunisian travels: "I have finally discovered colour."

But why Arles of all places? Degas once spent a summer there. Adolphe Monticelli – painter of pastose colourful still-life flowers – was for van Gogh a kind of éminence grise because of the former's disagreement with his Parisian colleagues. He, too, lived in nearby Marseilles. Zola was born in this area, in Aix-en-Provence, where Cézanne had also been living for a long time. Apart from this, the Arles women were said to be the most beautiful in the world. Van Gogh himself never mentioned any specific reasons for his choice of Arles. However, his departure from Paris in February was most certainly an escape from the dreary melancholy of the Parisian winter.

Van Gogh wrote to his sister shortly after his arrival: "I have no need for Japanese art here, since I tell myself that I am in Japan, and only need to open my eyes and take in everything before me." As if to verify these words to himself, he chose to paint the most typical Japanese motifs in his early Arles paintings. *Pink Peach Trees ("Souvenir de Mauve")* (p. 35), painted in March 1888, was actually there before his very eyes. Even more satisfying to van Gogh than the joy of the approaching spring, which the small tree clearly heralded, was his hope of a Far Eastern culture directly on his doorstep. Instead of using Hiroshige's woodcuts – as he did in Paris – to visualize a Japanese landscape, he was now able to experience it himself in reality. The blooming tree, protected from the Mediterranean mistral by fencing, represented his own optimism and became a symbol of his own wishes and projection of his desires.

For five francs a day – way above his limits – he rented a room in a restaurant. The small attic was completely unsuitable for a studio. He did not know anybody who could sit as his model, and so the area around Arles, the trees, hills, bridges, fishing huts became his sole motif. The Camargue, the marshy Rhône delta, still largely uncultivated in the 19th century, the Crau plateau with

"Now, since I have seen the ocean with my own eyes, I feel completely how important it is for me to stay in the south and to experience the colour which must be carried to the uttermost – it is not far to Africa."

VINCENT VAN GOGH

OPPOSITE:
Still Life: Vase with Twelve Sunflowers
Arles, August 1888
Oil on canvas, 92 x 73 cm (36¼ x 28¾ in.)
Bayerische Staatsgemäldesammlungen, Neue Pinakothek, Munich

its cornfields and vineyards and the beach near the pilgrimage town Saintes-Maries-de-la-Mer sated his appetite for nature, which had been triggered by two years of living in the city. On his long walks he hoped to improve his somewhat shaky health, which he had abused with his excessive intake of alcohol and tobacco, as well as lack of decent food.

Perhaps he was reminded of his Dutch homeland – at any rate he was drawn more and more to the canal, south of Arles, where he studied the bridge and its surroundings. The two versions of the Langlois drawbridge (below and right) were painted in March and May 1888. The peaceful serenity of the motif, the wide expanse of sky and water and the few objects in the painting were put under tension by his experimentation with colours: the motif itself merely provides the scenery over which colour is stretched like a second skin. The later version is in this respect the more restrained of the two. The distant view from the embankment, with the extensive tract of sky and too little water, of the opposite-facing bridge in contre-jour light, of people on the bridge recognizable only as shadows, and in addition the light, white-toned application of colour, are all reminiscent of the Impressionists' techniques which most obviously influenced

Bridge at Arles (Pont de Langlois)
Arles, March 1888
Oil on canvas, 54 x 65 cm (21¼ x 25½ in.)
Kröller-Müller Museum, Otterlo

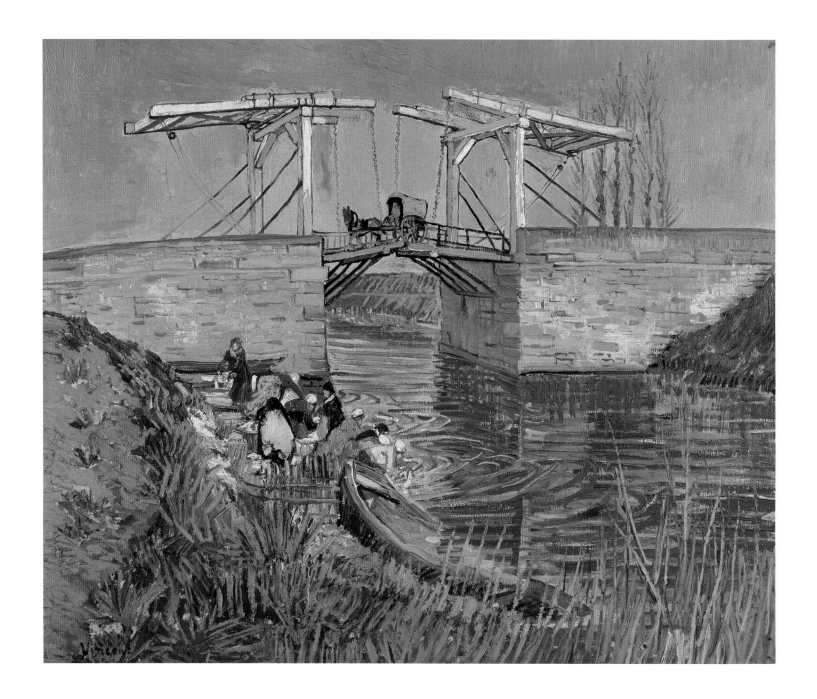

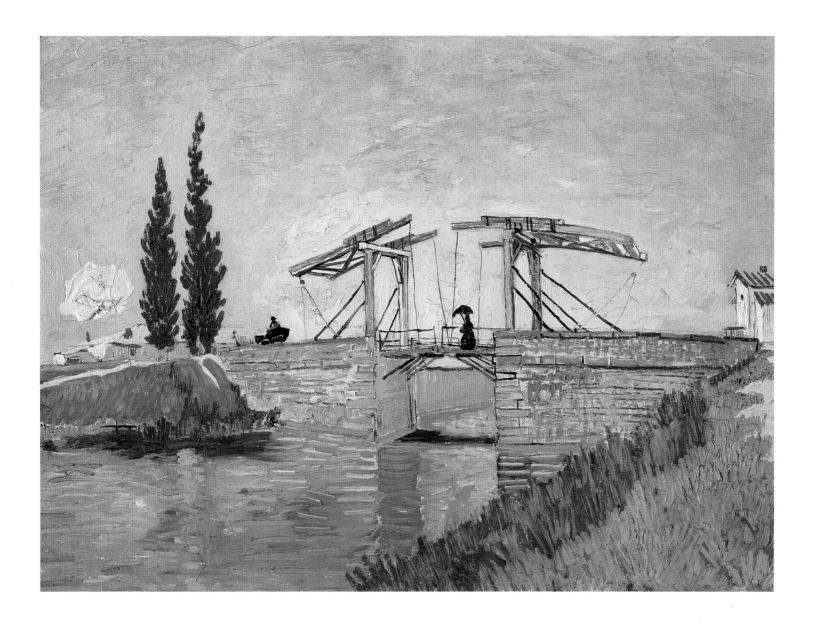

van Gogh here. The early version is completely different. The artist is standing directly on the banks of the canal. Objects now stand out sharply against the lofty horizon and have the appearance of radiating colour from themselves, mainly due to the use of red tonality combined with all the colours. Here the directed, participating, binding view geared towards the concrete object makes itself felt; this is a technique that Vincent was to cultivate gradually during his Arles period.

In so doing van Gogh developed a new form of tone painting, which is better than that of his master Delacroix. Autonomy of colour and tone painting are one here. Just as before, the colouring of the picture arises out of the play on varieties of one specific colour and tones – the only difference now being that this basic colour no longer corresponds to reality. A rich yellow, a gaudy red now rise above the mere task of portraying an appearance. Colour alone is the means of expressing oneself individually, as well as portraying the idea of reality present in the artist's psyche. Light and shadow, reflections and refractions of colour are deliberately subdued, but these qualities of the painting still have their pictorial origin in actual perception and not in mere imagination. A certain colour is no longer chosen because it corresponds to the actual, but because it is able to strengthen the vehement nature of expression. This colour is no longer objectively verifiable, but only subjectively understandable.

The Langlois Bridge at Arles
Arles, May 1888
Oil on canvas, 49.5 x 64.5 cm (19½ x 25½ in.)
Wallraf-Richartz-Museum, Cologne

Still there is little reason for such vehemence of expression. On the contrary, paintings such as *The Harvest* (p. 36) of June 1888 take complete pleasure in what is seen. Here van Gogh painted a typically traditional landscape scene, indeed he used a richer intensity of colour, but it is clearly close to reality in the toned-down shade of the delicate blue in the background.

Soon after his arrival, Vincent looked for another cheaper room in a café and at the same time he rented a house, his famous "yellow house", which he gradually furnished. At least from May onwards he had studios at his disposal and a place to store his numerous new paintings. He was still completely optimistic at this time.

Once a year on the 24th of May, Europe's gypsies flock to the small fishing village of Saintes-Marie-de-la-Mer to honour their patron saint, St Sarah, and take part in a pilgrimage. The whole region is in complete turmoil, thronged full of half-fearful, half-curious people. Naturally van Gogh's interest was aroused. His excursions in the area around Arles came to an end with his journey to the Mediterranean coast. *Fishing Boats on the Beach at Saintes-Marie-de-la-Mer* (p. 37), painted at the beginning of June 1888, takes up and reworks a theme from the earlier period: the beach scene. Now the sea is literally pushed to the edge of the painting and its atmospheric blue is barely distinguished by the line of the horizon from the similar composition of the sky, and thus is a mere piece of scenery for the graphic exactness of the thing itself. With an almost dissecting accuracy of observation, van Gogh is fully engrossed in the material nature of the banal motif, in the surging movement of the hull and the tilted intricacy of the mast. He presents objects almost lovingly – boats, vases, chairs, shoes – creating a visual panorama.

The autonomy of colour does not go hand-in-hand with the autonomy of form. The form of an object, its contours and surface composition remain in his work true to reality all of the time: "It's true I turn my back completely on nature, when I transform a sketch into a painting, decide upon the colours, enlarge or simplify, but in relation to the actual form I am afraid of moving too far away from reality and thus of not being exact enough." This he admitted in a letter to the artist Bernard. He continued: "I don't in fact invent the whole painting, on the contrary, I discover the thing, but it must come out of nature." Van Gogh approached subjects which he would later use in his pictures not by making quick sketches but by drawing in more exact detail. The concrete motif remained the constant foundation of his representations, over which colour was placed like a second skin, colour which van Gogh chose solely according to its effect in the painting. In this way the dignity of the object remained intact.

OPPOSITE:
Pink Peach Trees ("Souvenir de Mauve")
Arles, March 1888
Oil on canvas, 73 x 59.5 cm (28¾ x 23½ in.)
Kröller-Müller Museum, Otterlo

34

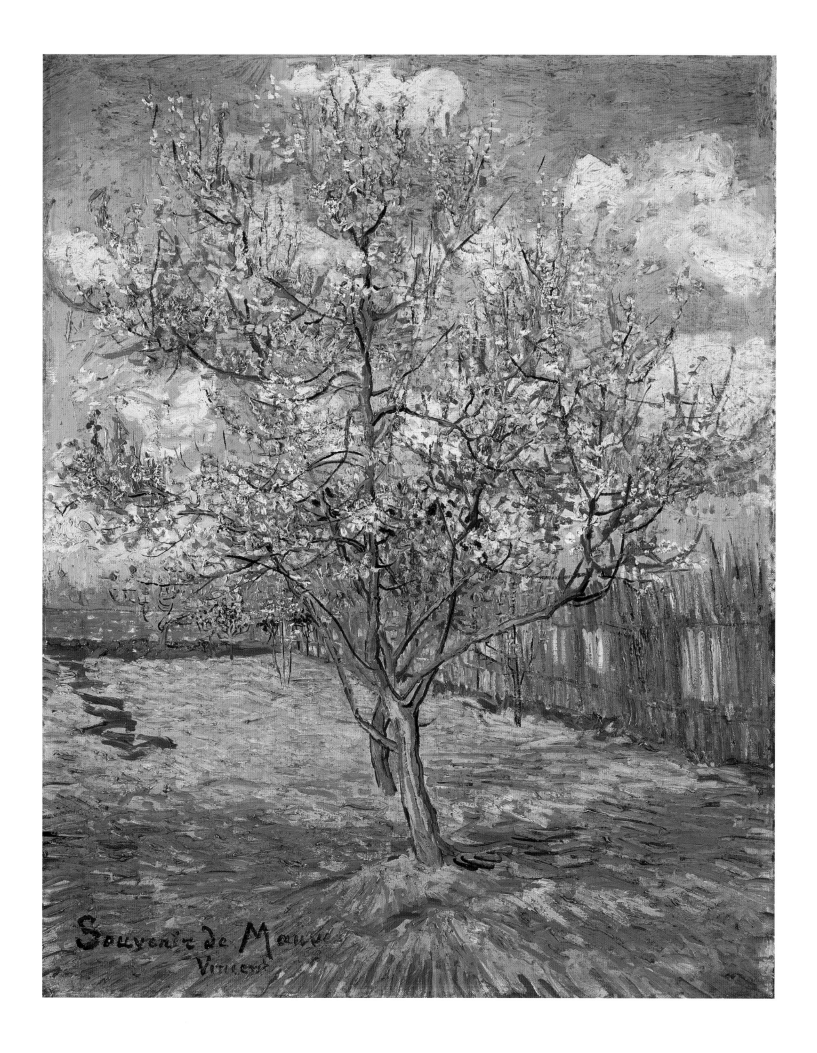

Souvenir de Mauve
Vincent

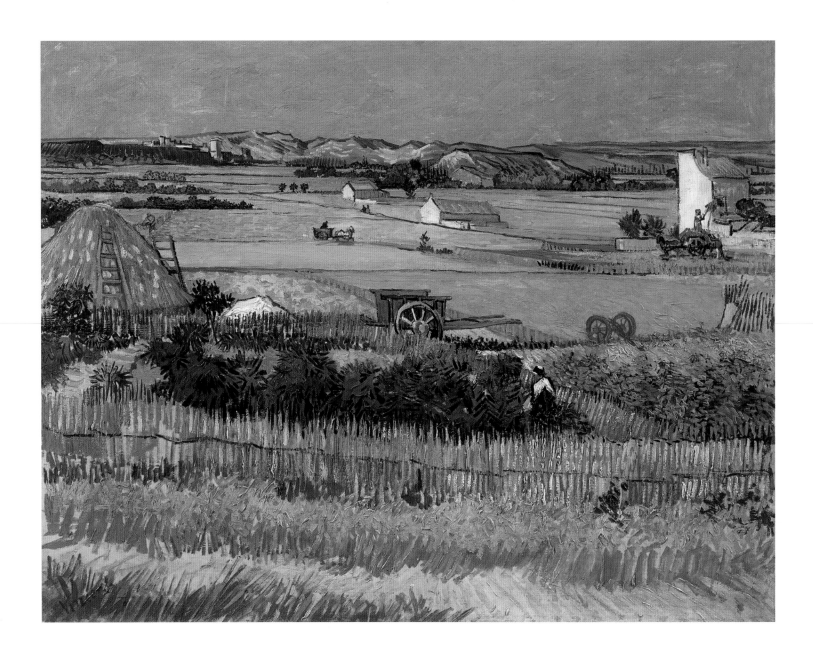

The Harvest
Arles, June 1888
Oil on canvas, 73 x 92 cm (28¾ x 36¼ in.)
Van Gogh Museum (Vincent van
Gogh Foundation), Amsterdam

"An endlessly flat landscape – seen from a bird's
eye view from the top of the hill – vineyards,
harvested corn fields. All this is multiplied to
infinity and spreads like the surface of the sea to
the horizon, which is bordered by the hills of
Crau."

VINCENT VAN GOGH

Thus the red-haired eccentric lived amongst the people of Arles: taciturn, introverted, added to the fact that as an artist he was considered as lacking a respectable profession, constantly in need of money, and saddled with an unpronounceable name, a fact which van Gogh had taken into account early on by signing his works with his Christian name only. So it was almost half a year before he was able to make close friends with the people he admired and whose portraits he wanted to paint. Portrait painting was van Gogh's way of examining in an artistic light the people, friendship and affection which were so often denied him in life. He himself said that the art of portrait painting "lets me develop that which is the best and deepest within me". The colours thus become increasingly the means by which characters are depicted, as well as becoming more and more independent of the concrete externalities of the object portrayed. In a certain sense, the people he painted were all, like himself, outsiders. Strangely enough, he never painted a portrait of his brother Theo, not even during his time in Paris.

The Seated Zouave (p. 39), portraying an infantry soldier from Algeria and painted at the end of June 1888, is van Gogh's first portrait since that of Père Tanguy. "I've finally found a model," rejoiced van Gogh about the African who

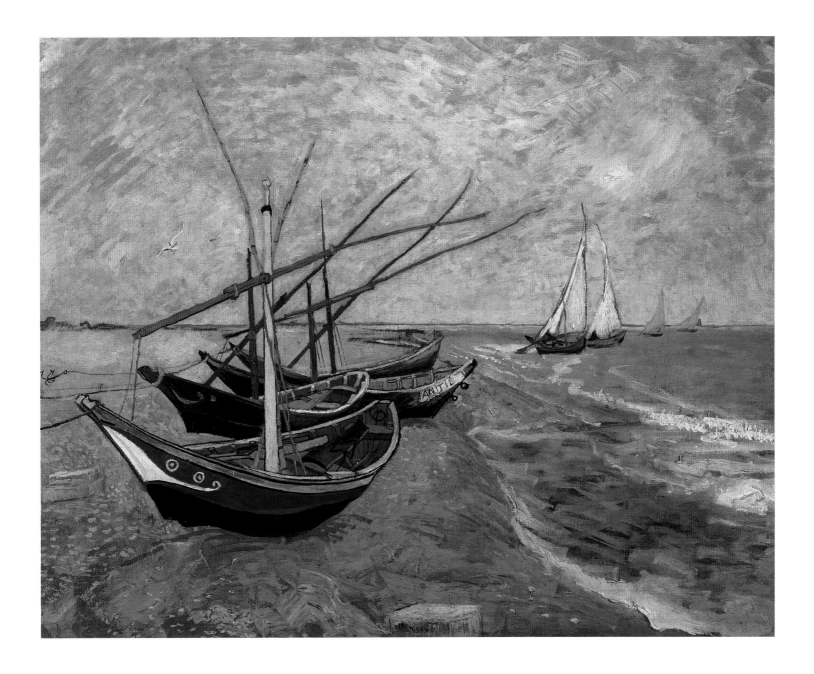

was on holiday in Arles. Milliet, the name of the soldier, later characterized van Gogh accurately in his remark: "This young man who shows both talent and good taste in his drawings becomes abnormal as soon as he touches a brush."

As always this portrait was not commissioned. His main reason for painting it was the exotic appearance of the man in his unusual traditional costume, which reminded him of Delacroix' models, whom the latter came across in Morocco. A strange contradiction between spatiality and flatness is typical of this depiction. The perfectly captured natural facial expressions are all the more pronounced because of the decorative patterns of the clothing, contrasting with the pastose colouring behind. The tiled floor appears to slip away towards the foreground of the picture, leading to the model's rather precarious posture.

The few people who van Gogh portrayed during this time appear to have been pushed into a framework in order to maintain an unbroken artistic style. This fact alone points to the impossibility of these portraits having been commissioned. The originality of those portrayed is stressed in their faces, which are all the artist tries to capture exactly; the posture, clothing, application of colour and composition are, in contrast, more the result of wanting to create a decorative effect, which is not dependent upon contradictions but which only becomes

Fishing Boats on the Beach at Saintes-Maries-de-la-Mer
Arles, June 1888
Oil on canvas, 65 x 81.5 cm (25½ x 32 in.)
Van Gogh Museum (Vincent van Gogh Foundation), Amsterdam

"Spent a week in Saintes-Maries … on the really flat sandy beach with small green, red and blue boats, which in their form and colour are as pretty as flowers. One man alone uses them. These skiffs rarely ever go on the high seas. They set off when there is no wind blowing and return to land as soon as the wind becomes too strong."
VINCENT VAN GOGH

The Zouave (Half Length)
Arles, June 1888
Black chalk, pen, watercolour,
31.5 x 23.6 cm (12½ x 9¼ in.)
The Metropolitan Museum of Art, New York

"I've finally found a model – a Zouave – a small chap with a bull's neck and tiger's eyes; I began a portrait and then began a second one … the uniform is of the same blue as the enamel pans, with faded orange-red braid and two stars on his chest; a common blue, which was very difficult to get exactly right."

VINCENT VAN GOGH

OPPOSITE:
The Seated Zouave
Arles, June 1888
Oil on canvas, 81 x 65 cm (32 x 25½ in.)
Private collection, Argentina

apparent when colour is applied. Van Gogh was proud of the fact that he deliberately painted his portraits in a hurry: "One must strike while the iron is hot," he wrote, and compared his style to the quick gestures of the caricaturist, above all Honoré Daumier. This desire to work quickly explains the by-and-large expansive backgrounds and the ornamental play of the colours of the clothing, which appear to be totally separate from the bodies of the persons portrayed.

La Mousmé, Sitting (p. 40) and *Portrait of the Postman Joseph Roulin* (p. 43) were painted shortly after each other in the summer of 1888. La Mousmé, whom van Gogh described as "a Japanese girl, in this case one from the provinces, 12 or 14 years of age" and Joseph Roulin, whom he described as "having a head like Socrates" are both sitting in the same easy chair which was in van Gogh's "yellow house". The chair appears too large for the girl, whose slight frame is swamped by the wickerwork. The country postman, in contrast, sits erect, but appears ill-at-ease in his attempt to accommodate himself comfortably amongst the confinement of the furniture. The girl's skirt and the man's uniform are not mere articles of clothing, but rather great ornamentally worked areas of colour. The faces, in contrast, are finely painted. The shy, nervous glance of the child and the choleric, bloated face of the adult make the concrete appearance of the ordinary people from the neighbourhood comprehensible. These portraits are dedicated to portraying the theme which had so fascinated van Gogh in his early works: simple people from the area, captured by the intense observation of an artist who feels at one with them.

Throughout the whole of the summer, van Gogh was occupied with a problem which had troubled his fellow artists for centuries, of how one should portray darkness using colour when painting night scenes. How could one make colour, which only comes alive when in contrast with light, flexible so that the opposite, darkness, is portrayed? Van Gogh appears to have found the key to this problem on a walk at night along the seashore. "It wasn't cheerful, it wasn't sad, it was just – beautiful," he wrote to Theo afterwards, deeply moved. He wanted to portray this atmosphere, of sparse light in front of a dark horizon, in his paintings.

Mainly in order to get used to working by artificial light, he painted *The Night Café in Arles* (pp. 44–45) in September 1888. For four days or so he slept only during the day, returning at night to the depressive milieu of the dive which he wanted to paint: lonely drunks cowering behind their tables, a billiard player, a couple cuddling in the corner, and a waiter – a cast of characters enacting despair.

"I have tried," Vincent commented on his painting, "to portray with red and green this terrible human suffering. The room is blood red and dull yellow, a green billiard table in the middle, and four lemon-coloured lamps radiating an orange and green aureola light. Struggle and antitheses are present everywhere: in the completely opposite colours (the greens and reds), in the crouching sleeping figures of the night, in the empty, depressing room, in the violet and blue." And elsewhere Vincent remarked: "I attempted to convey the idea that the café is a place where one can ruin oneself, become crazy or criminal." This painting is one of the few which solely portrays the motif of a pessimistic feeling of life. The image of the café, a place where "one can ruin oneself", get drunk and spend one's last penny, was to follow van Gogh through the last few years of his life up until his own collapse.

The night atmosphere in this painting comes out more through its association with loneliness, suffering and desperation than through the portrayal itself. Only the yellowish aureoles around the lamps point to the fact that the picture

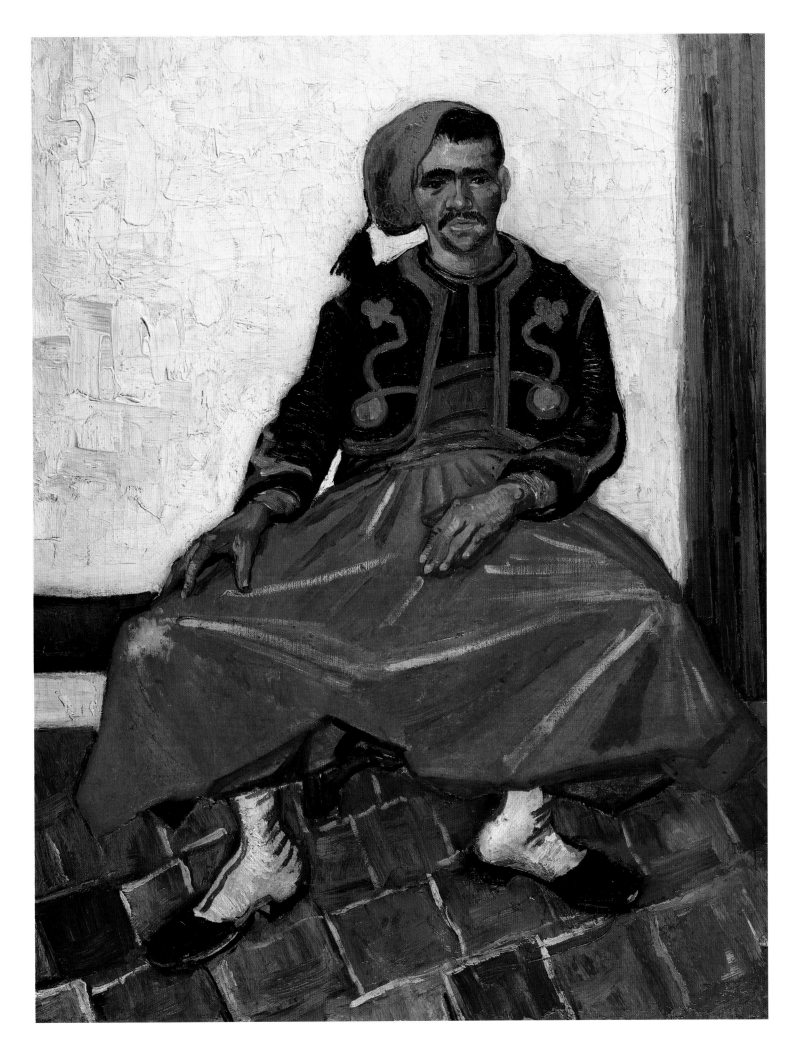

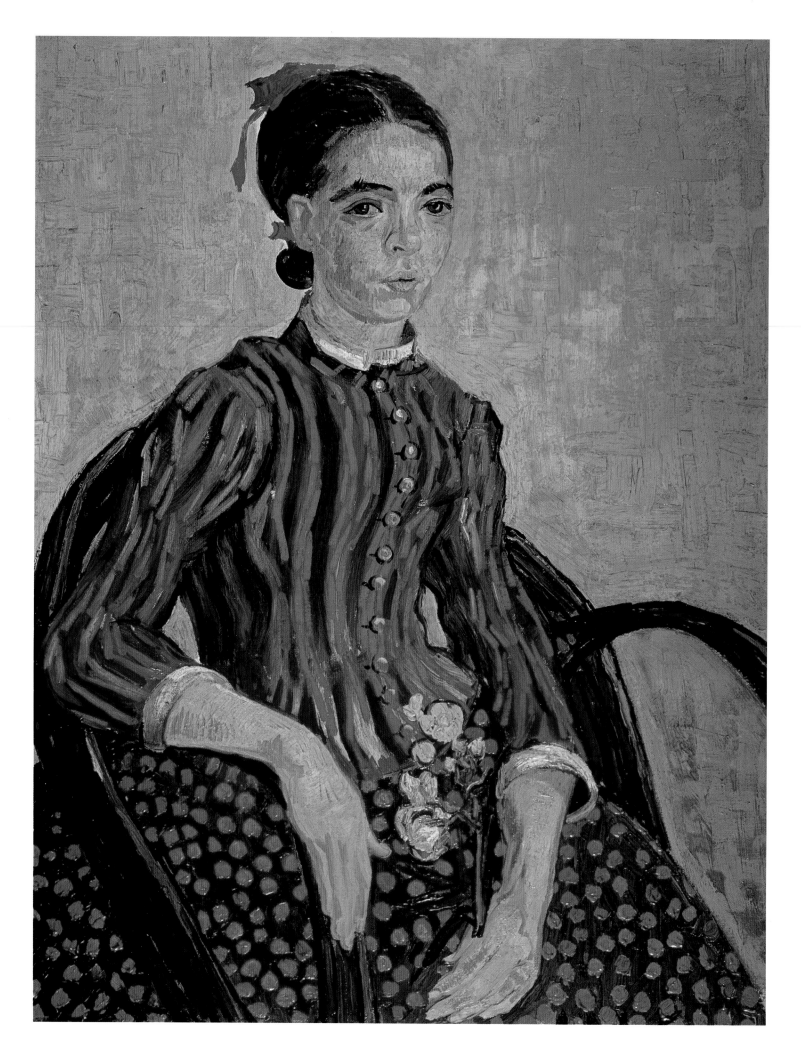

was painted at night. Yet *The Night Café* is still only a stepping stone, an étude of night painting.

A short time afterwards, with his painting entitled *Terrace of a Café at Night (Place du Forum)* (p. 47), van Gogh dared to take the final step into the open. Beneath the starry sky the terrace appears brightly lit up, its reddish yellow a complementary contrast to the dark blue of the twilight. A strong pull into the black centre of the painting, recognizable by the virtually parallel receding lines above the lintel in the front, pergola and house gables, set off the inviting light of the café in addition to its dark ambience. The light spots of stars in the sky, added to the complementary contrast which is difficult to achieve with sparse light, makes the representation of a night scene quite matter-of-fact.

To paint outdoors was a 19th-century achievement. To paint by artificial light was already in the Baroque period a favoured artistic way of passing the time. But to paint outdoors at night by artificial light was van Gogh's very own invention. In this way he presents a crass contrast to the light painting of the Impressionists, stressing a precision of observation in his portrayal of dimly lit objects, to which the technique of painting outdoors is perfectly suited. "The night is livelier and richer in colour than the day," van Gogh exclaimed enthusiastically. The vaguely recognizable objects spur on the depiction of exactness and fantasy. Van Gogh continues to use the technique of painting at night throughout the remaining few years of his life, his greatest achievement being *Starry Night* (p. 71).

Van Gogh's painting of his *Yellow House* (p. 49) of September 1888, although not a night painting, keeps to the same colours as *Terrace of a Café at Night*. Shortly after he rented the house in May, van Gogh had it painted yellow, which was an important and symbolic colour for him. Yet for a long time it stood completely without furniture, due to the fact that he had no money to furnish it. Only when Theo sent him 300 francs was he able to afford sparse furnishings. He finally moved in in the middle of September. Now he felt like his own master – security and freedom appeared guaranteed thanks to his "ownership", added to the possibility of finally founding the long-awaited artist commune. Out of sheer joy he painted all the houses yellow in his painting, as if they were all at his disposal. For a short while the "yellow house" symbolized everything which appeared important to him and which guaranteed him happiness. The "yellow house" was a personal symbol.

At the end of the century Symbolism was an attitude of mind which was to confront van Gogh again and again, especially with regard to his artistic and private disagreement with Gauguin. "The aim of painting and literature," Edouard Dujardin, himself one of the chief theoreticians of Symbolism, wrote in 1886, "is to reproduce the discovery of things with the common means of painting and literature. What one should express is not the image, but the character." Symbolism spread like a fashion craze through the young generation of Bohemian artists. The aim was "to portray the essence of the chosen object and in so doing avoid mere photographic imitation".

Van Gogh's painting *Still Life: Vase with Twelve Sunflowers* (p. 30) of August 1888 attempts to portray this very essence. With extreme precision he has captured the flowers, yet the pastose application of colour, the confused arrangement of outstretched leaves, and the inner luminosity of the light blue background, give the portrayal a significance which goes far beyond that of the mere painting of the flowers. These sunflowers stand for the artist's imagination, for his identification with them, for some form of deeper meaningfulness, and they appear to have influenced him.

La Mousmé, Sitting
Arles, June 1888
Pencil and pen, 32.5 x 24.5 cm (12¾ x 9½ in.)
Pushkin Museum, Moscow

OPPOSITE:
La Mousmé, Sitting
Arles, July 1888
Oil on canvas, 74 x 60 cm (29 x 23½ in.)
National Gallery of Art, Washington

PAGE 42:
Portrait of the Postman Joseph Roulin
Arles, August 1888
Pencil, 31.8 x 24.3 cm (12½ x 9½ in.)
J. Paul Getty Museum, Los Angeles

PAGE 43:
Portrait of the Postman Joseph Roulin
Arles, early August 1888
Oil on canvas, 81.2 x 65.3 cm (32 x 25¾ in.)
Museum of Fine Arts, Boston, Gift of Robert Treat Paine 2nd

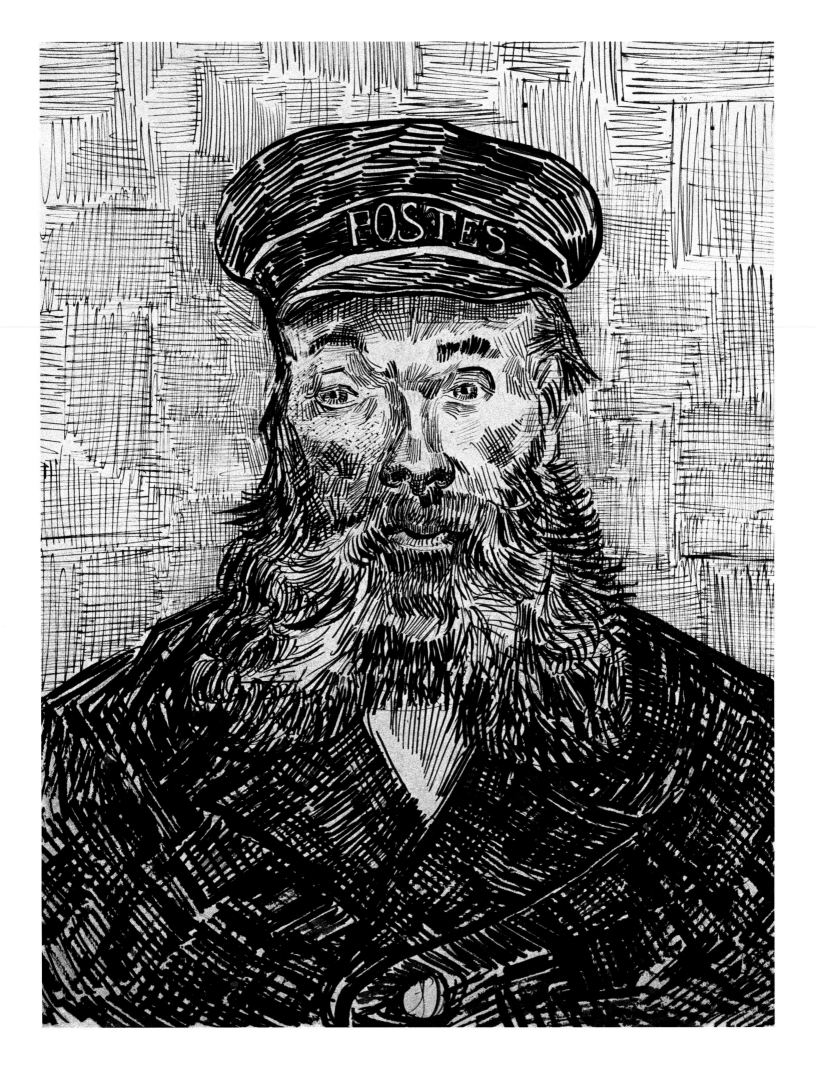

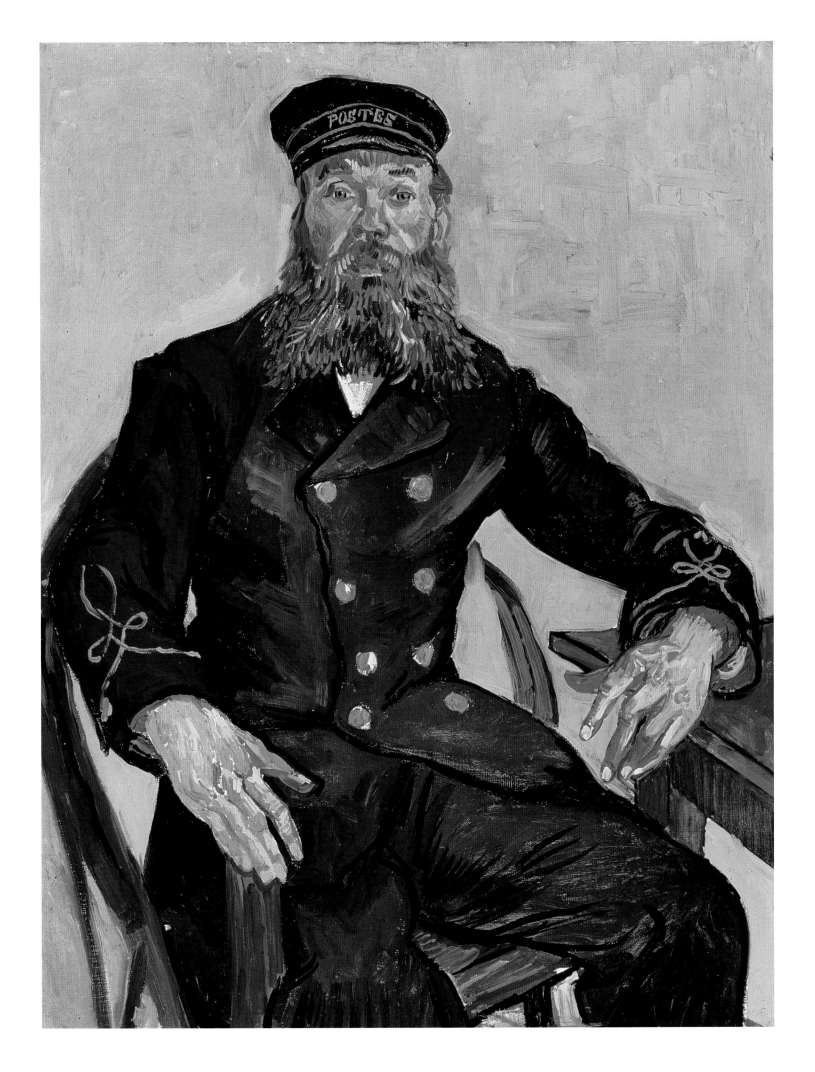

"In my painting of the 'Night Café' I've tried to express the idea that the café is a place where one can ruin oneself, become crazy and criminal. Through the contrast of delicate pink, blood red and dark red, of mild Louis-XV and Veronese green against the yellow-green and stark blue-green tones – all this in an atmosphere like the devil's inferno and pale sulphurous yellow ... I've tried to convey the sinister power of such a place."
VINCENT VAN GOGH

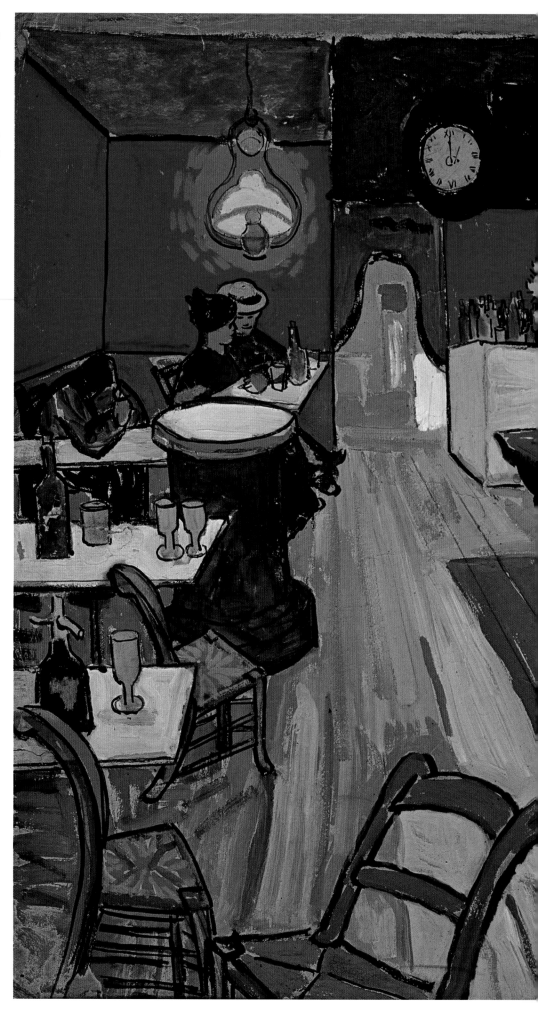

The Night Café in Arles
Arles, September 1888
Watercolour, 44.4 x 63.2 cm (17½ x 25 in.)
Collection H.R. Hahnloser, Berne

The Café Terrace on the Place du Forum, Arles, at Night
Arles, September 1888
Reed pen, 62 x 47 cm (24½ x 18½ in.)
Dallas Museum of Art, Dallas

"A cafe in the evening, seen from the outside; on the terrace little figures are seated drinking. A gigantic yellow lamp lights up the terrace, the house fronts and the pavement, and casts out its light onto the street cobbles, which take on a pink violet colouring. The house façades in the street, under a blue starry sky, are dark blue or violet, in front a green tree. There you have it – a night painting without having used the colour black, only beautiful blue, violet and green, and in this setting the lit-up café takes on a pale sulphurous yellow and lemon colouring."

VINCENT VAN GOGH

OPPOSITE:
Terrace of a Café at Night (Place du Forum)
Arles, September 1888
Oil on canvas, 81 x 65.5 cm (32 x 25¾ in.)
Kröller-Müller Museum, Otterlo

"A watering can, a harrow left in the fields, a dog in the sun, an ugly church-yard – all these things can become a receptacle of my revelation. Each of these objects and thousands of other similar ones, which one normally merely glances over with indifference, can, for me personally, at any one moment – but in no way controlled by myself – take on an exalted and stirring character." With these words Hugo von Hofmannsthal described the power of imagination in his "Chandos Letter".

It was exactly this wish to empathize with the most banal of worldly objects which was to inspire van Gogh. The wild movement of the plants in his painting *Still Life: Vase with Oleanders and Books* (p. 52) points to the same arbitrary search for a world behind the objects. However, artistic Symbolism as represented by a Dujardin or a Hofmannsthal was always the conscious, deliberate demonstration of artistic genius, the display of an omnipotent fantasy, which set the artist apart from the commonness of the world. Van Gogh's power of imagination, however, came from his innermost self. It was an expression of a vehement will, a flood of emotion, which later was to contribute to his mental derangement. The worlds portrayed in his paintings are much more self-explanatory, more immediate than the often affected exoticism and esoteric meanings of the Symbolist movement. Van Gogh was not an aesthete influenced by the spirit of that time.

A major pictorial technique of the Symbolists was the framing of all the objects by a common contour. This expressed the uniqueness of the object that had inspired the artist, or even the final vagueness of the things, which was necessary in order to make symbols out of them and to stylize them so that they went beyond being mere symbols. Dujardin called this method of painting "Cloisonnism", derived, on the one hand, from mediaeval goldsmiths' art, on the other hand, as was always the case in that period, from Japanese woodcuts.

Van Gogh's *L'Arlesienne* (p. 51) of November 1888, a portrait of Madame Grinoux, the owner of the station café in Arles, is a perfect example of this Cloisonnism. The back of the chair, the table top, and the woman's figure are all embraced by a single contour, which emphasizes the silhouette. Van Gogh works the contrasting colour effects into the spacious graphic framework. The depiction is completely flat and details come alive entirely from the line of colour. Van Gogh explains his Cloisonnism thus: "The areas which are surrounded by contours, whether present or not – but in any case tangible – are then filled out with simplified tones."

Cloisonnism was the trademark of the "Pont-Aven School", whose mentor was Gauguin. He almost dogmatically surrounded surface areas with framing lines. They were his guarantee against the mere copying of reality. Van Gogh, in contrast, viewed the whole less strictly. His contours, mostly varied in colour, came to the surface, or remained below the surface according to need, since the effect of the picture as a whole, and not a theoretical concept, determined their usage. Gauguin's criticism of van Gogh's inexactitude in this area was one of the reasons which led to their later disagreement.

In the painting *The Trinquetaille Bridge* (p. 56) of October 1888, van Gogh almost completely renounced the use of colour. Thus the effect of the painting became subordinate to the contrasting play of linear interweavings on the left-hand side and the larger calmer surface on the right. This view of the bridge over the Rhône – the river itself is not shown in the picture – is based in its lack of colour on his earlier Dutch work, but the motif points to the work done in Paris. Yet the extreme distortion of the area and the confused perspective of the picture point to his later years. The steps in the foreground are drawn into the

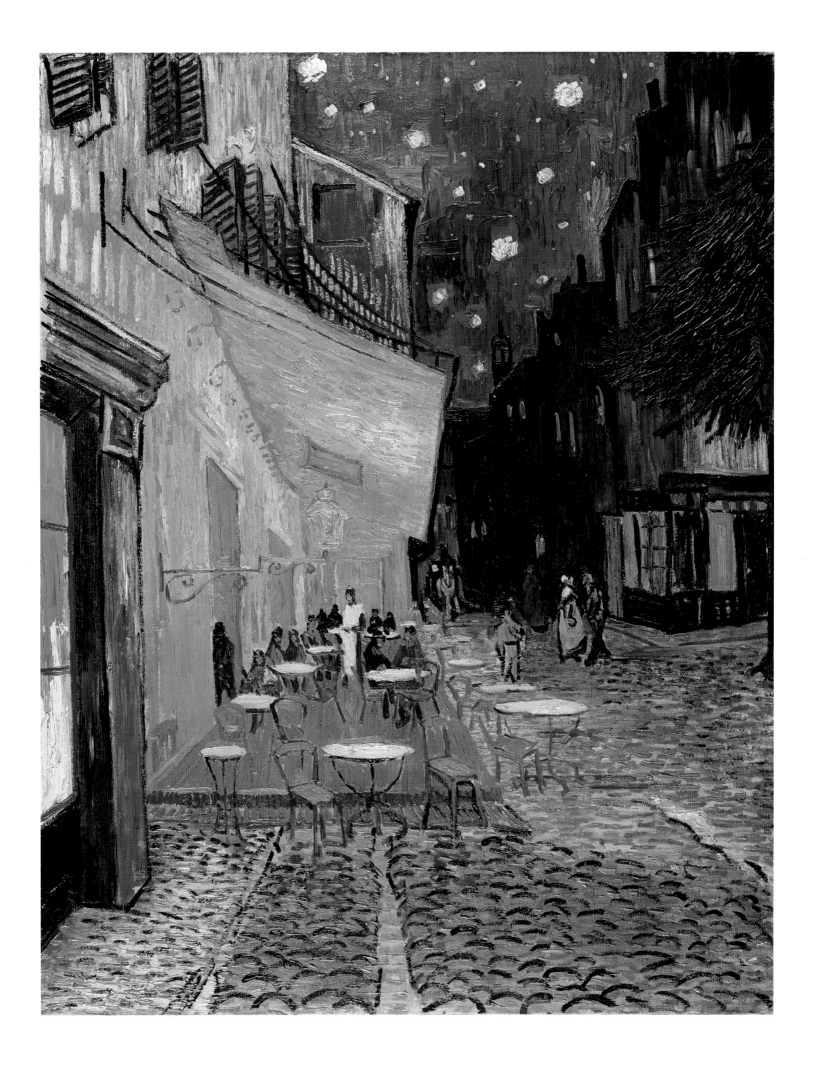

The Yellow House
Arles, September 1888
Pen and ink, 13 x 20.5 cm (5 x 8 in.)
Private collection, Switzerland

"Now we're experiencing a glorious heat wave without any wind – that just suits me. A sun, a light, which for lack of a better word can only be called yellow, pale sulphurous yellow, pale lemon gold. Oh, how lovely this yellow is."

VINCENT VAN GOGH

back of the picture, into the hole, which blocks out the underpass thereby serving as a contrast to the precarious equilibrium of the steel bridge, which threatens at any moment to collapse. One can call it expressivity of space: this constant fragile balance, this precarious ease. Was van Gogh therefore the first Expressionist? His handling of space suggests the answer is yes.

Van Gogh's treatment of colour leads to a similar conclusion. It is primarily representative of his means of expression. Pictures such as the two versions of *The Sower* (pp. 54 and 55) of June and November 1888, were in their intensity of colour, in their courageous use of colour and in the vehemence of colour application unparalleled at that date. The enormous pastose disc, representing the sun, immerses the whole background, the sky, in a rich yellow. The front of the picture, the soil, is covered in a hazy blue, shimmering violet: a total reverse of the colours in reality. The real yellow field becomes blue, the real blue sky yellow. The only decisive factor is the contrasting effect of colours.

However, these pictures are in no way abstract. All of them stick to concrete reality as a foundation which is covered by colour as a means of the artist's expression. Here lies van Gogh's actual expressiveness. He presents a detail from everyday life and at the same time an interpretation by means of colour and composition. And this interpretation only when in contrast with the concrete appearance exposes the vehemence of his expressive will and the temperamental artistic gesture. A second reality, artistically pure and subjective, pushes the first aside.

"As long as people work like people with their heart and soul, aiming to do their best, it doesn't matter how bad they are at their job, a certain priceless

something attaches itself to manual work," was Ruskin's apologia on craftmanship. Van Gogh too was concerned with manual work on canvas, which only then made sense of the whole. He was the first artist to use an individual expression, favoured by Ruskin, rather than apparently perfect handling, expressive gestures rather than academic beauty in his work, not as a conscious pictorial interpretation of the theoretician, but as a common view acquired in his daily use of colour and brush. The dignity of the individual as a creative being was a moral view. The problem which Ruskin and van Gogh had to cope with – the former theoretically, the latter in practice – was that expression does not also mean the conveyance of a message, but in fact freedom of artistic gesture is the first step in breaking down the public's understanding.

The indifference which confronted van Gogh throughout his life and thus also in Arles meant that positive stimuli became increasingly rare. The fund of stimulating themes, the landscape, some portraits, had long been exhausted. The artistic debate with his fellow artists, which had kept up his spirits in Paris, was missing in the enclave of the provinces. Challenges for his work came less and less from his environment. This environmental reality was such an important stimulus to him. Van Gogh clung more and more to the single utopia which art left him: the old ideal of a free, self-contained artists' commune. This utopia had

"My house here is painted butter yellow on the outside and has solid green window shutters; it is located directly in a square with a green park full of plane trees, oleanders and acacias. And inside all the walls are painted white and the floor is tiled in red. Yet the most striking thing is the glaring blue sky. Inside the house I can really live and breathe and think and paint."

VINCENT VAN GOGH

Vincent's House in Arles (The Yellow House)
Arles, September 1888
Oil on canvas, 72 x 91.5 cm (28¼ x 36 in.)
Van Gogh Museum (Vincent van Gogh Foundation), Amsterdam

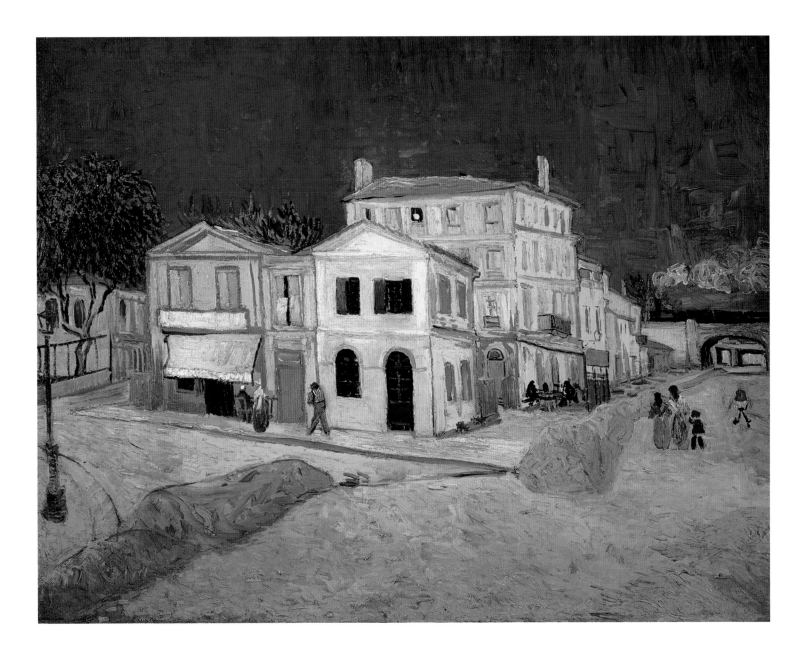

been fulfilled for a long time by Gauguin. Founding the "Atelier du Midi" with Gauguin, which was supposedly to precede an institute in which Bernard, Seurat and Signac would also be involved, became the predominant single theme of his letters written in Arles. All the pictures van Gogh painted from that summer on indicate this anticipation: they were to decorate the "yellow house", their shared studio, and it was to be the starting point and basis for fruitful artistic debates. Gauguin was really going to come. Thus the "Arles tragedy", mostly understood to be the cause of van Gogh's breakdown, took place. The grotesquerie with Gauguin began.

Gauguin had left Paris at roughly the same time as van Gogh, but he did not retreat to the south. Instead he went to the less expansive, scenically more wild, and according to him unspoilt Brittany. Here he lived in the village of Pont-Aven, continually threatened with debts, occasionally sought out by his friends, more or less taking each day as it came. He felt himself to be an undiscovered genius, but had the same wish as van Gogh – to found an artists' circle. He thought of Bernard, of Anquetin, but never of van Gogh as members of this artists' circle. As a far-off goal he dreamed of France's colony Martinique, in the faraway tropics, where he would find his real fortune. But the shortage of money was his only handicap.

Theo van Gogh exhibited Gauguin's works at his gallery. With his increasing debts Gauguin became more and more dependent on Theo's financial support, just as Vincent was in faraway Arles. Vincent was to use Gauguin's misery to his own purpose when he forced his brother to incite Gauguin to come to Arles. In Vincent's mind Gauguin was already with him. Gauguin hesitated to move in with this eccentric whom he did not value highly as an artist. Added to this he mistrusted Theo: "However much Theo likes me, he would definitely not agree to support my living in the Midi only because of my beautiful eyes. He studied the terrain with the cold eyes of a Dutchman and contemplated the view of following the thing as far and as exclusively as possible," Gauguin wrote in October 1888 to Bernard. Gauguin believed Theo's motives were geared towards a business ruse.

Gauguin's feelings of resentment put Vincent even more in a flurry. He thought his humble abode in Arles was not attractive enough for Gauguin. He began to buy furniture, only the best and most comfortable for Gauguin, while he himself was content with a modest bed and the smallest room. The whole of van Gogh's paintings bore the mark of Gauguin's expected arrival. He painted a series of sunflower paintings (p. 30), a yellow-in-yellow study, as decoration for the "yellow house". The decorativite quality of van Gogh's paintings of this

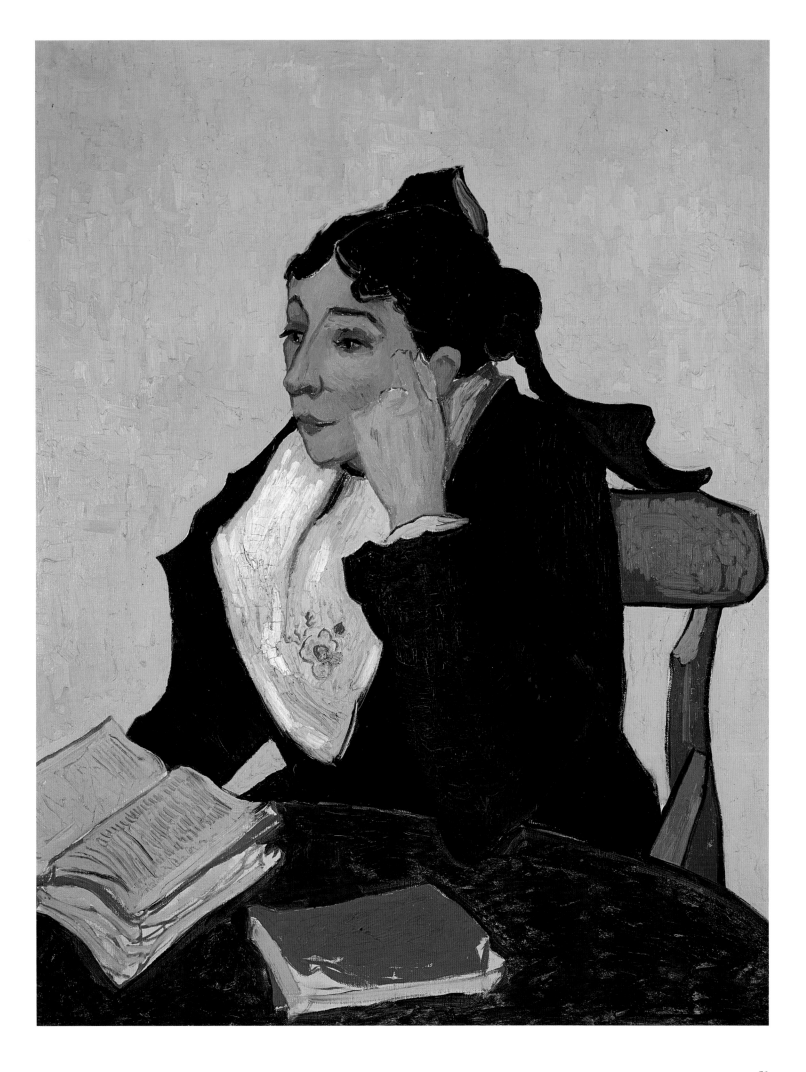

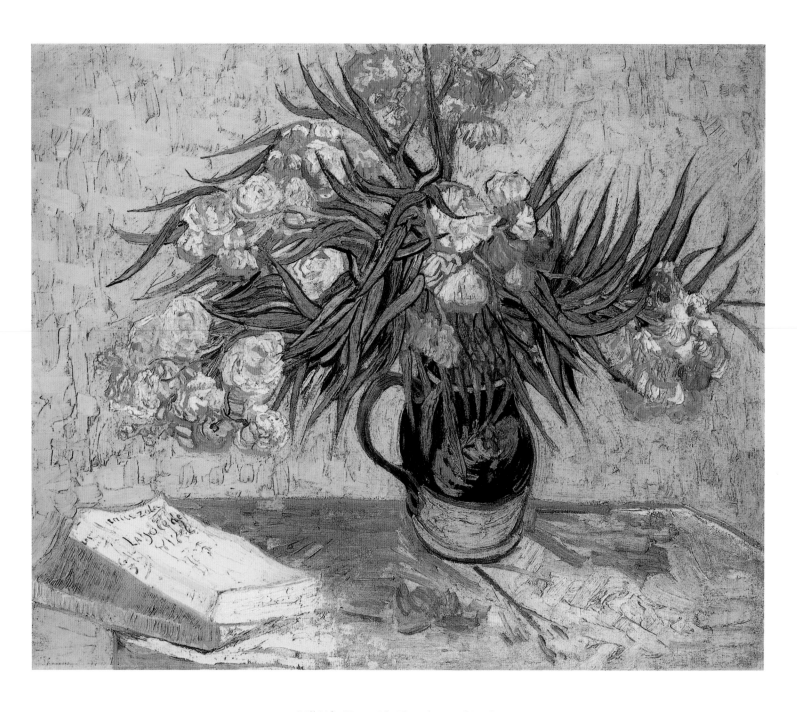

Still Life: Vase with Oleanders and Books
Arles, August 1888
Oil on canvas, 60.3 x 73.6 cm (23¾ x 30 in.)
The Metropolitan Museum of Art, New York

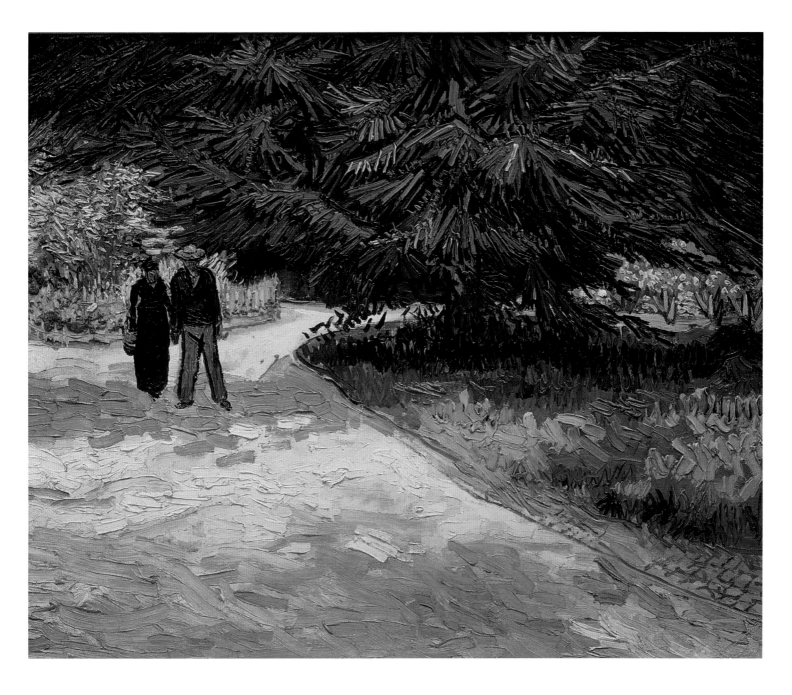

Public Garden with Couple and Blue Fir Tree:
The Poet's Garden III
Arles, October 1888
Oil on canvas, 73 x 92 cm (28¾ x 36¼ in.)
Private collection

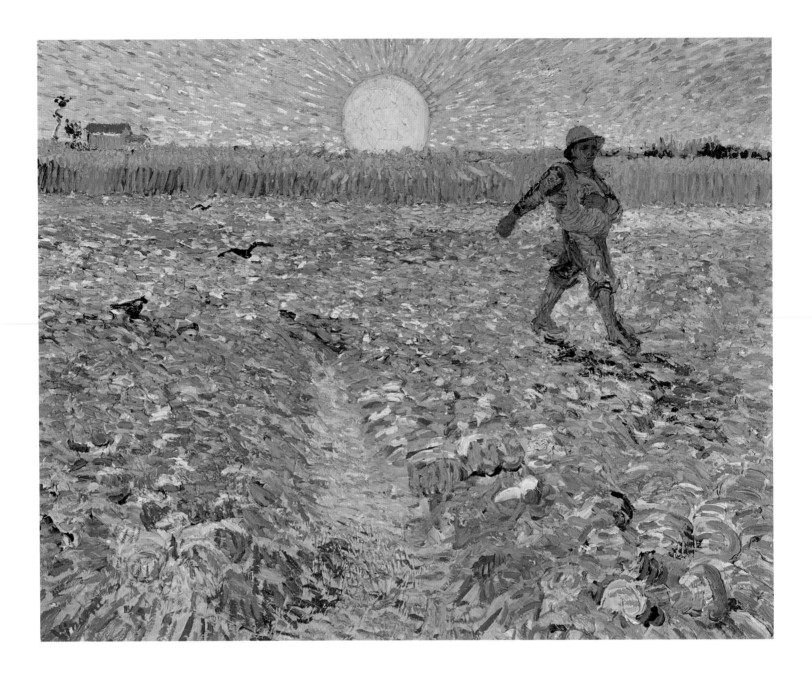

The Sower
Arles, June 1888
Oil on canvas, 64 x 80.5 cm (25¼ x 31¾ in.)
Kröller-Müller Museum, Otterlo

"However, the painter of the future will be a colourist, such as has never yet existed. Manet was working towards it, but as you know the Impressionists have already got a stronger colour than Manet. This painter of the future – I can't imagine him doing the rounds of the local dives, having false teeth and frequenting the Zouave brothel like me."

VINCENT VAN GOGH

period is explained by the fact that he saw them as decoration rather than works of art. They were intended to document van Gogh's artistic standard, as a starting point for a painting competition with Gauguin, but were to be no more than items of furniture. Van Gogh was determined to paint beautifully. After all, he attached great importance to Gauguin: "Everything which he does has something soft, calming, amazing about it," van Gogh wrote at the end of May. "People do not understand him yet and he is suffering because he has not sold anything – just like other true poets."

In Gauguin's honour he named his depiction of the park in Arles *Public Garden with Couple and Blue Fir Tree: The Poets' Garden III* (p. 53). It was to hang in a prominent place in Gauguin's room. Yet still there was no trace of Gauguin. Again and again he postponed his departure from Brittany, which people were constantly urging him to undertake, finding excuses in letters and financial loop-holes in order to justify his hesitation. Then finally after Theo had finished paying all his debts, Gauguin arrived in Arles in the early hours of the morning of the 23rd October.

Van Gogh was on top of the world. He gladly let Gauguin take the lead role in art, placing himself in the role of the student, who, however, wanted to show

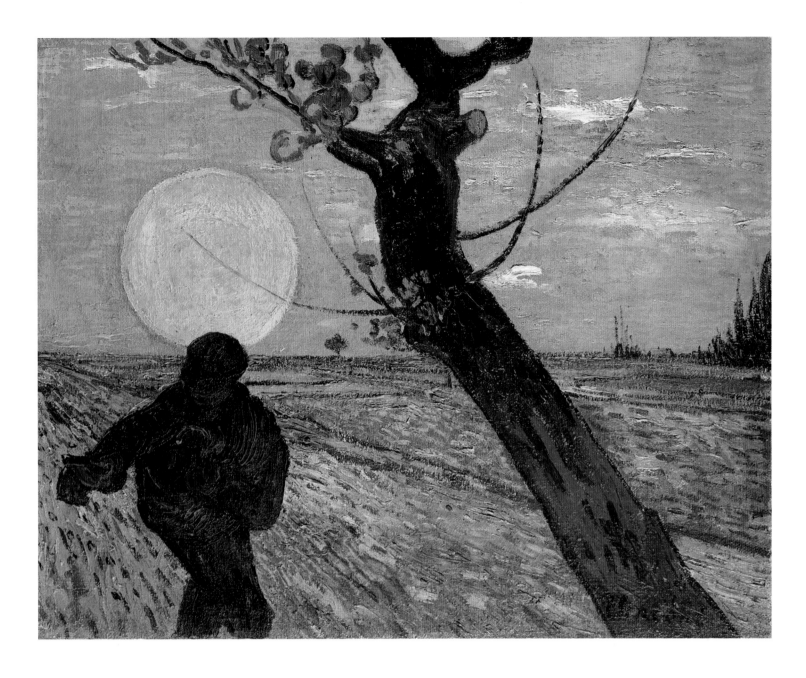

what he had learnt. They worked out a lot of motifs together, compared their results and argued over artistic concepts. Van Gogh was much too impulsive, impatient and too tied to the arbitrariness of the fantasy for the considered tactician and rationalist Gauguin, who in December 1888 cried out: "He is a romantic, I myself tend to the primitive. In applying colour he loves the impulsive, whilst I hate disorderly undertakings."

For a while van Gogh appeared to bow to Gauguin's theories: he outlined all areas and did not work any more according to nature. Instead the abstraction of "painting from the head" took over; he set himself to using Gauguin's artistic ways, just as he did in Paris, until it reached mere imitation. But now he was too certain of his own talents: "At that time the abstract appeared very inviting to me. But, oh dear, it is a bewitched land! And one is soon confronted by a wall," he tried to explain to Theo. Gauguin's way was simply not his own.

Their collaboration was not to continue for much longer. Gauguin felt himself to be a victim of a game of intrigue between the two brothers; he suspected they wanted to belittle his artistic meaning. Van Gogh himself was disappointed that his honest will to subordination and his willingness to learn found no recognition. Though it was only differences on artistic questions at first, the effect

The Sower
Arles, November 1888
Oil on burlap on canvas,
73 x 92 cm (28¾ x 36¼ in.)
Foundation collection E. G. Bührle, Zurich

"This man will either become mad or else leave us way behind."

CAMILLE PISSARRO

The Trinquetaille Bridge
Arles, October 1888
Oil on canvas, 73.5 x 92.5 cm (30 x 36½ in.)
Private collection

"The Trinquetaille bridge with all those steps was painted on a grey morning; stone, asphalt, cobbles, everything is grey, the sky is a pale blue, the figures colourful, a sickly small tree with yellow foliage."

VINCENT VAN GOGH

on their pride and understanding of themselves was not long in coming. Gauguin complained to Theo: "The incompatibility of both our characters means that Vincent and I cannot live together peacefully. It is imperative that I leave."

Vincent saw his entire dream shatter and felt his utopia of an artists' commune, which he had wanted to try out with Gauguin, finally disappear. As symbols of loneliness he painted his and Gauguin's chair in December (opposite). They both stand vacant, metaphors for the artists who have now departed from where they previously had chatted to one another. Van Gogh's more modest wooden chair with the pipe and tobacco pouch as elemental symbols contrasts with Gauguin's more elaborate armchair with candle and book, indicative of learning and ambition. Van Gogh painted his chair yellow and violet, which at that time were symbolic of daylight and hope, as seen in the painting *The Yellow House*. Against this the red and green colours present a complementary contrast in the painting of Gauguin's chair, just like the red-green of the *The Night Café* picture which documents darkness and lost hope. Day and night stand opposite one another in the two artists, and also as alternatives of a future life. Gauguin, as the message appears to convey, illuminated the night for van Gogh.

"Ever since I wanted to leave Arles, he has been behaving so strangely that I hardly dare to breathe. 'You want to leave,' he said to me and as soon as I answered in the affirmative he tore a piece, containing the following sentence, from the newspaper: 'The murderer has fled'," Gauguin was later to recall in a letter. Gauguin as a murderer, a murderer of hope and trust. Van Gogh really appeared to be going mad. More than once he got up in the middle of the night and crept to Gauguin's room to see whether he was still there. It was van Gogh's illness that kept Gauguin in Arles: "In spite of a few differences I can't be angry with a good chap who is ill and suffering and calling for me."

But on 23rd December the threatening situation escalated. Gauguin went for a walk in the evening and van Gogh, suspicious as ever, followed him. Gauguin, who heard the familiar steps approaching nearer and nearer, turned around and looked straight in van Gogh's disturbed face. Van Gogh was supposedly holding a razor blade in his hand. Gauguin spoke softly to Vincent, who then turned around and went back home. Gauguin, disturbed by the whole incident, spent the night at a hotel. When he returned to the "yellow house" the next morning, the whole of Arles was already up and about. Van Gogh, plagued by hallucination, had cut off one of his ears with the razor blade which Gauguin claimed to have seen earlier in his hand. After van Gogh had temporarily managed to stop the bleeding, he wrapped the lacerated ear in a handkerchief and ran with this to the town brothel in order to give it to a prostitute. As if nothing had happened he returned home and slept. In this state the police, who had by this time been informed, found him. He was then taken to the town hospital.

Meanwhile Gauguin left secretly. As a salve to his conscience he later wrote in his autobiography that van Gogh had threatened him with a knife. In a letter to

Self-Portrait with Bandaged Ear
Arles, January 1889
Oil on canvas, 60 x 49 cm (23½ x 19¼ in.)
Courtauld Institute Galleries, London

Bernard, shortly after this one of 23rd December, he never even mentioned the episode. One can assume that van Gogh did not want to hurt Gauguin that evening; rather, he only wanted to alleviate the latter's suspicion. Gauguin used the whole episode as a long-awaited excuse to justify his finally leaving Arles. The way Gauguin got out of the whole affair, without even seeing Vincent one last time, does not put him in a particularly good light.

After that Vincent stayed in the hospital for fourteen days. Back in his studio he painted the result of the catastrophe: his *Self-Portrait with Bandaged Ear* (opposite). The whole of the right side of his face is covered by a large, wide bandage which adds a sad seriousness to the artist's almost rigid appearance. Inside a thick coarse cape he appears to be seeking protection from a hostile environment. The gay colour of a Japanese woodcut frames the left side of his face in stark contrast to the whiteness of the bound wound. The woodcuts are reminiscent of the Père Tanguy portrait, but this one is uncontrolled, without normality. The episode with Gauguin was truly an experience that made him realize his own limits.

Van Gogh was no longer his old self. The loneliness which he had learned to accept in the previous years as the price for the formation of an artists' commune, was not to leave him in future. "I don't dare to ask other painters to come here after what has happened. They risk losing their mind, just like me," he wrote with resignation to his brother in February 1889. In the next year he was to experience a loneliness partly chosen, but also one which was forced upon him.

Four weeks after his discharge from hospital, van Gogh had to return again. Signs of persecution mania appeared, and he began to imagine that someone wanted to poison him. A petition signed by the inhabitants of Arles sealed his final internment. The resentment against van Gogh, which had always been present in spite of his search for recognition, now led him to avoid any form of contact with people completely. This resentment had driven him out of Holland and made his stay in Paris difficult. Looked after by a priest and a doctor, he lived until the beginning of May both as patient and prisoner in the Arles hospital. In addition to this he was worried about Theo getting married in Paris, because he was afraid of losing his one-and-only confidante.

In order to escape the constraints of the asylum he began painting again. Paintings such as *Orchard in Blossom with View of Arles* (p. 60) and *The Courtyard of the Hospital at Arles* (p. 61), both of April 1889, may not give a direct hint of the utter desperation he felt during this time. They document more banal incidents of daily life rather than his suffering. However, a claustrophobic atmosphere is conjured up in these paintings: the confinement of the hospital courtyard, which despite the splendid flowers blocks out the view of the distant horizon, and the withered poplars, which thrust themselves like iron bars in front of the town panorama, present an impassable barrier between the artist's position and the object of his dreams – the town and its freedom.

Van Gogh came to terms with his situation very quickly. The world, to which he clung and which piece by piece was being taken away from him, did not accept his religious, political and artistic views, and he resolved not to bother it any longer. He entered the mental hospital of his own free will, but against the wishes of his brother, whom Vincent tried to prepare for this decision: "I have tried to get used to the idea of starting afresh, but at this present time it is impossible for me. I am afraid of losing my ability to work, which is now coming back to me, if I take on too much and get bogged down with the idea of opening a new studio. And so I wish to stay here for a while, both for my own peace of mind, as well as for that of others." On 8th May 1889 he moved to Saint-Rémy.

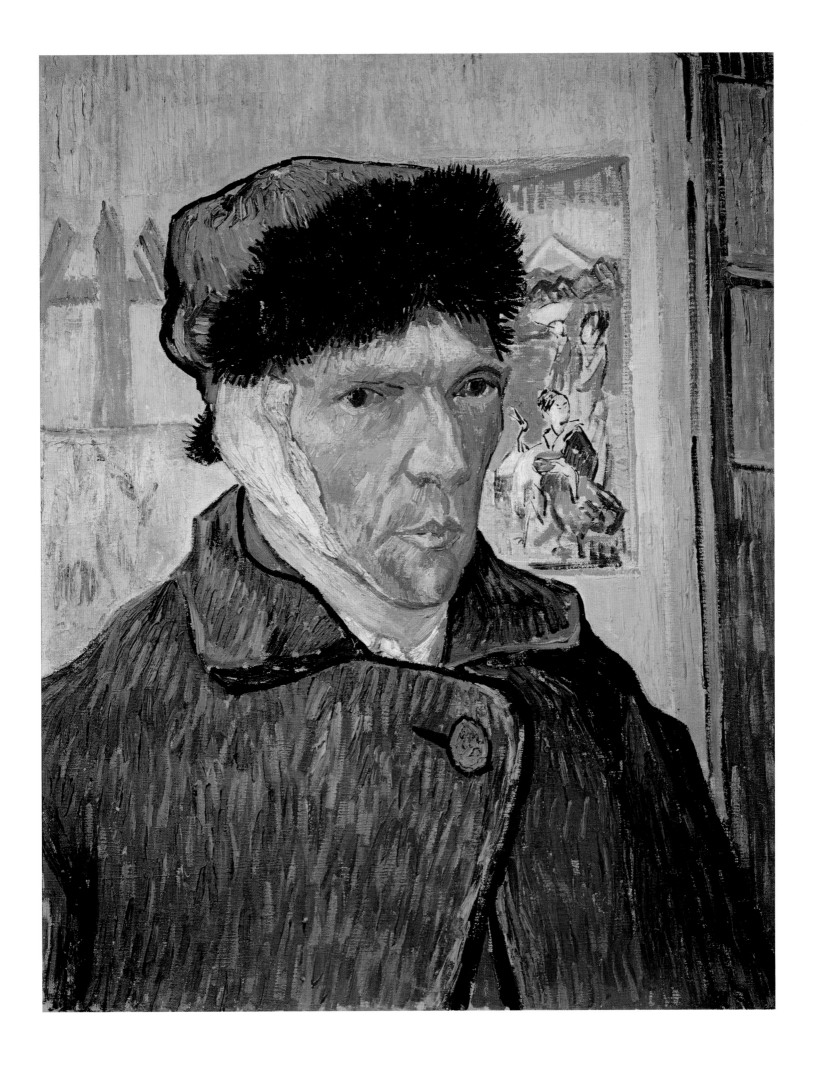

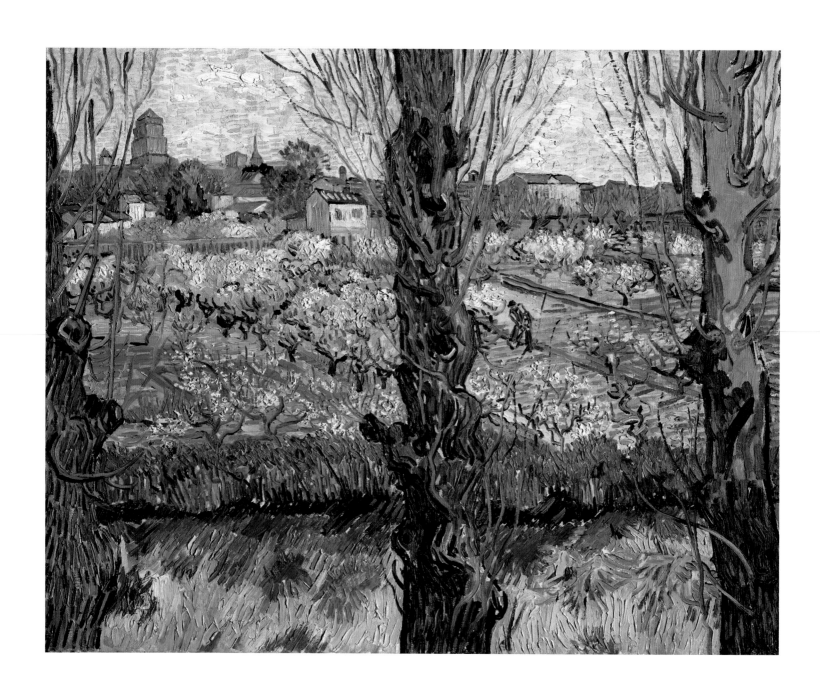

Orchard in Blossom with View of Arles
Arles, April 1889
Oil on canvas, 72 x 92 cm (28¼ x 36¼ in.)
Bayerische Staatsgemäldesammlungen,
Neue Pinakothek, Munich

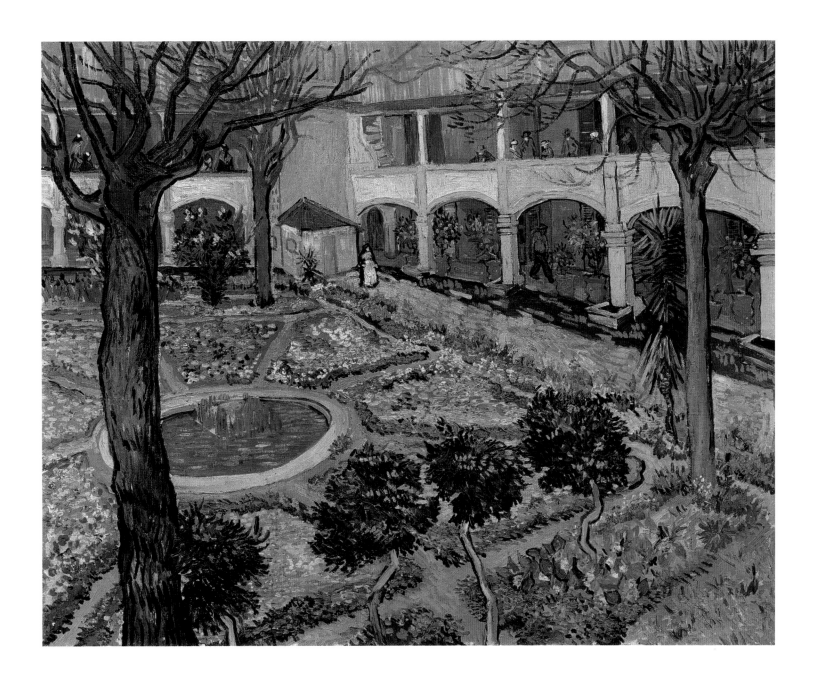

The Courtyard of the Hospital at Arles
Arles, April 1889
Oil on canvas, 73 x 92 cm (28¾ x 36¼ in.)
Oskar Reinhart collection "Am Römerholz",
Winterthur

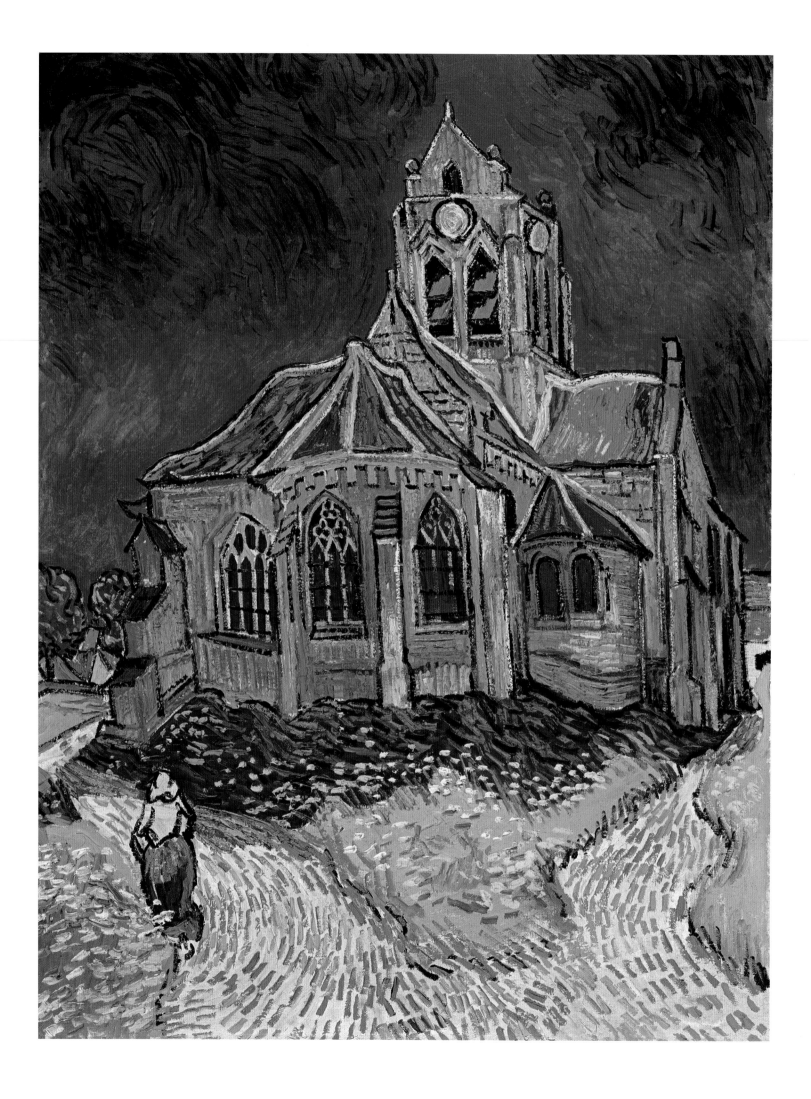

Painting as Life
Saint-Rémy and Auvers 1889–1890

"To suffer without complaining is the only lesson one should learn in this life," van Gogh wrote in May 1889 to his brother Theo, although he had every reason to wrangle with his fate. At the age of 36 Vincent went of his own accord into the Saint-Paul-de-Mausole nursing hospital for the mentally ill near Saint-Rémy-de Provence, 17 miles from Arles.

His hopes and plans for the future were completely destroyed. The incurable illness came increasingly to the fore, and the attempt by the locals of Arles to have him put away lay heavy on his heart. He felt discarded by society, and Theo's approaching wedding left him fearful of losing the support of his helpful, beloved brother, added to the failure of his most desirous dream, a communal "studio of the south", which was shattered upon Gauguin's departure.

The insight "that I finally feel incapable of taking a new studio and of staying there alone, neither here in Arles, nor anywhere else ... I would like to stay temporarily in the asylum, because of my own peace of mind as well as that of others", was hard-won, although he had long ago broken with all conventions. There was nothing left for him to do but to accept his situation: "I am ready to play the role of a madman, although I have not at all the strength for such a role." Despairing, he clung to his brother: "If I didn't have your friendship, I would be driven to suicide without giving it a second thought, and cowardly as I am I would do it in the end."

The asylum, where van Gogh spent almost a year, was about two miles from Saint-Rémy in a rather lonely district, surrounded by cornfields, vineyards and olive groves – motifs which appear again and again in his paintings. Judging from the dark hallways and barred windows of the cheerless rooms, life in the mens' quarters must have been very depressing for him.

The patients were left completely alone, since the director of the asylum, Dr Peyron, who ruled it with rigorous thrift, just kept the patients alive and neglected to actually help them; he was not even a specialist in mental illnesses. Van Gogh received no medical attention apart from twice-weekly baths. Yet his life was more bearable in every sense than that of the other unhappy patients. He was allowed to withdraw, to read and work, and to leave the asylum so long as he was accompanied.

At this stage van Gogh was diagnosed as suffering from epileptic fits. Periodically he experienced fits of unpredictable length, going through a hazy stage, followed by a period of blankness; in between these episodes there were usually two to four weeks in which his behaviour was perfectly normal. The fits came unpredictably and there was generally quite a long period between each new attack. During attacks he often became violent and suffered from terrible

"I painted a large picture of the village church – the building has a violet appearance against a flat, deep blue sky of pure colour; the stained-glass windows are like ultramarine coloured spots; the roof is violet and orange in parts. At the front is something green in bloom and pink-coloured sun-burnt sand. It is almost like the studies I made of the old towers and cemetery in Nuenen – the only difference now being that the colour is more expressive and richer."

VINCENT VAN GOGH

OPPOSITE:
The Church at Auvers
Auvers-sur-Oise, June 1890
Oil on canvas, 94 x 74 cm (37 x 29 in.)
Musée d'Orsay, Paris

hallucinations. Normal activity, such as writing and painting, was completely impossible during this time.

Vincent viewed his own illness quite clearly and pragmatically. He accepted the unavoidable: "It consoles me that I can look upon my madness more and more as an illness like any other and thus accept it as such." In his letters to his brother he tried to hide how horribly depressing it was for him to have to live alongside the mentally ill and paranoid.

However, the ordered and monotonous life in the asylum contributed greatly to his regaining self-respect. He was allowed to go into the surrounding area and paint, accompanied by a guard, and he rested all his hopes on this; his work alone was capable of dragging him out of his deep depressions. At this stage, the fits did not leave any trace whatsoever in his work, since his periods of illness and those of artistic creativity were strictly kept apart.

Painting became an activity which directly connected him with life. The pictures painted during this period often give the impression of a hyperintensity which does not stem from illness, except in so far as he was possessed with a crazed creativity in the periods between his fits. It was as if he wanted to make up for lost time. These pictures also document his attempts not to give up, to

Irises
Saint-Rémy, May 1889
Oil on canvas, 71 x 93 cm (28 x 36½ in.)
J. Paul Getty Museum, Los Angeles

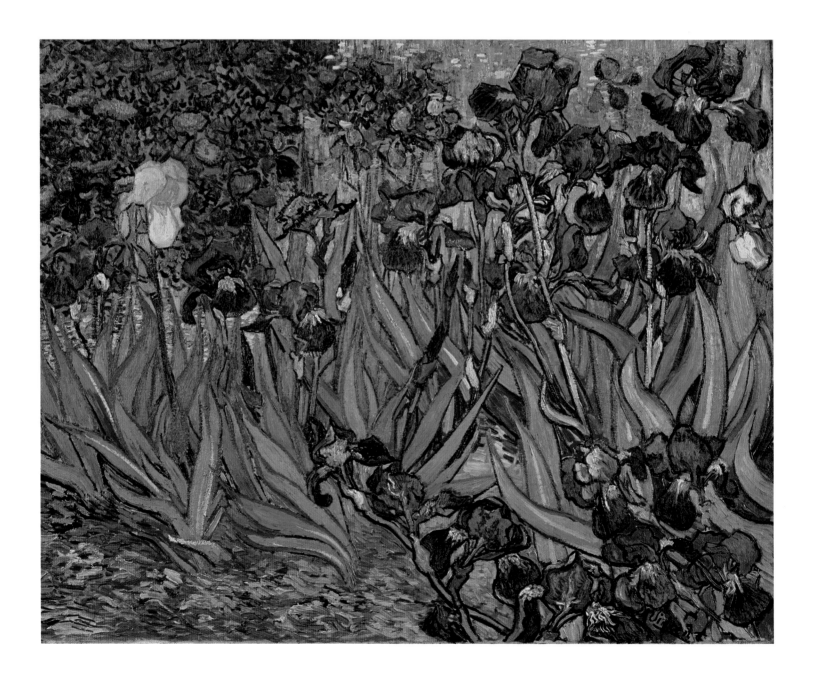

avoid renewed attacks by working ceaselessly and thus give vent to his intense feelings.

One of his first paintings done in Saint-Rémy is close to his flower paintings of Arles: *Irises* (p. 64). He came across this motif of voluptuous irises on his way to the flat of Dr Paul Gachet, whom Theo had recommended that he consult about his illness. The painting is crammed with the ripe, moist excesses of nature. The deep blue of the finely drawn iris buds contrasts sharply with the bold green of the leaves with their lancet tongue-like form, which divide the flowers into horizontal rows. The warm red of the soil firmly anchors the plants to the bottom of the picture, while the light green of the flowering meadow takes hold of the flowers from behind. As a stark contrast to all the colourfulness is a large open white iris to the left and at the far right of the picture is a pale blue iris which serves as an echo of the former.

In order for the eye to take in this brilliant display of flowers and arrange them accordingly, the canvas is divided up into different areas of colour, all of which – as in the flow of nature in summer – radiate light from within themselves, thereby creating a balanced, connected harmony. Thus the rich display of colour and variety of forms are not confusing; on the contrary, they support the lively movement of nature. The detail in the painting confirms this view – it is as if the artist had bent down to the flowers. The detail stands for the whole; nature is meant here, the principle of life.

Van Gogh was concerned most of all with getting as close to nature as was possible. Throughout his life this direct, near-erotic relationship to nature had been present: "It is not so much the language of painting as that of nature which one must listen to." To capture this liveliness was his primary aim in painting, which ought to plumb the "roots or the origin of the thing". Van Gogh wanted to penetrate as deeply as possible into life and feel at the same time the very beating of its heart.

As an ideal means of representation he had discovered colour and the actual life present within the colours themselves. He used colours in such a way that they took on a life of their own and thus were ideally suited to show optically the principle of life. His experimentation with colour never arose out of any particular painting technique, but rather was an ongoing struggle to find an adequate means of portraying a spiritual concern. Everyday objects around him were similes of life, and it was this that van Gogh wanted to express in his paintings. Colour had taken on an immediate representational value for existence, for life itself.

Van Gogh was concerned with verisimilitude in his depiction of human life. He allowed himself only one guideline: to portray reality itself, a contemporary, modern one and not one of a distant past. One could not achieve this by merely copying reality; what counted for van Gogh was what lay behind reality. He recognized a "rationale in the mysterious" meaning that "all reality was at the same time a symbol" – a religious way of viewing things.

This religious reality is clearly recognizable in his paintings, which are devoid of critical, caricature touches. His stance towards all his subjects is that of a loving person who accepts reality for what it is. He wanted to reach out to those people who accept the elemental things of life, such as nature, humanity, pain, joy, transitoriness ... A new philosophy of life was born which no longer saw the world through an earthly vale of tears and was not even a simple denial of a higher principle of life this side of the grave. He confronted the primaeval powers of existence, which he found in nature and out of which his natural mysticism arose, and this is evident in his paintings.

Cypresses
Saint-Rémy, June 1889
Pencil, reed pen and ink,
62.3 x 46.8 cm (24¼ x 18½ in.)
The Brooklyn Museum, New York

"The cypresses constantly occupy my thoughts – I want to paint something similar to my sunflower paintings. It's amazing that nobody has yet painted them as I see them; in their lines and proportions they are as beautiful as Egyptian obelisks. And the green is such a special fine tone. The cypress is a black mark in a sun-filled landscape, but it is one of the most interesting black tones, and I can't think of any other tone that was as difficult to capture. One has to see the cypresses here against the blue, or more correctly in the blue."

VINCENT VAN GOGH

"It is only too true that a lot of artists are mentally ill – it's a life which, to put it mildly, makes one an outsider. I'm alright when I completely immerse myself in work, but I'll always remain half crazy."

VINCENT VAN GOGH

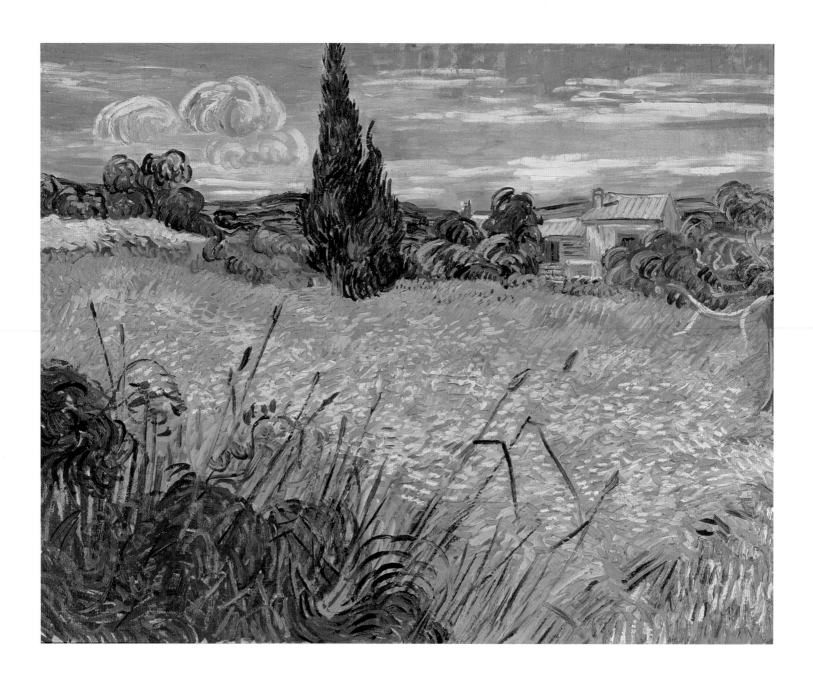

Green Wheat Field with Cypress
Saint-Rémy, June 1889
Oil on canvas, 73.5 x 92.5 cm (29 x 36½ in.)
Národní Gallery, Prague

OPPOSITE:
Cypresses
Saint-Rémy, June 1889
Oil on canvas, 93.3 x 74 cm (36¾ x 29 in.)
The Metropolitan Museum of Art, New York

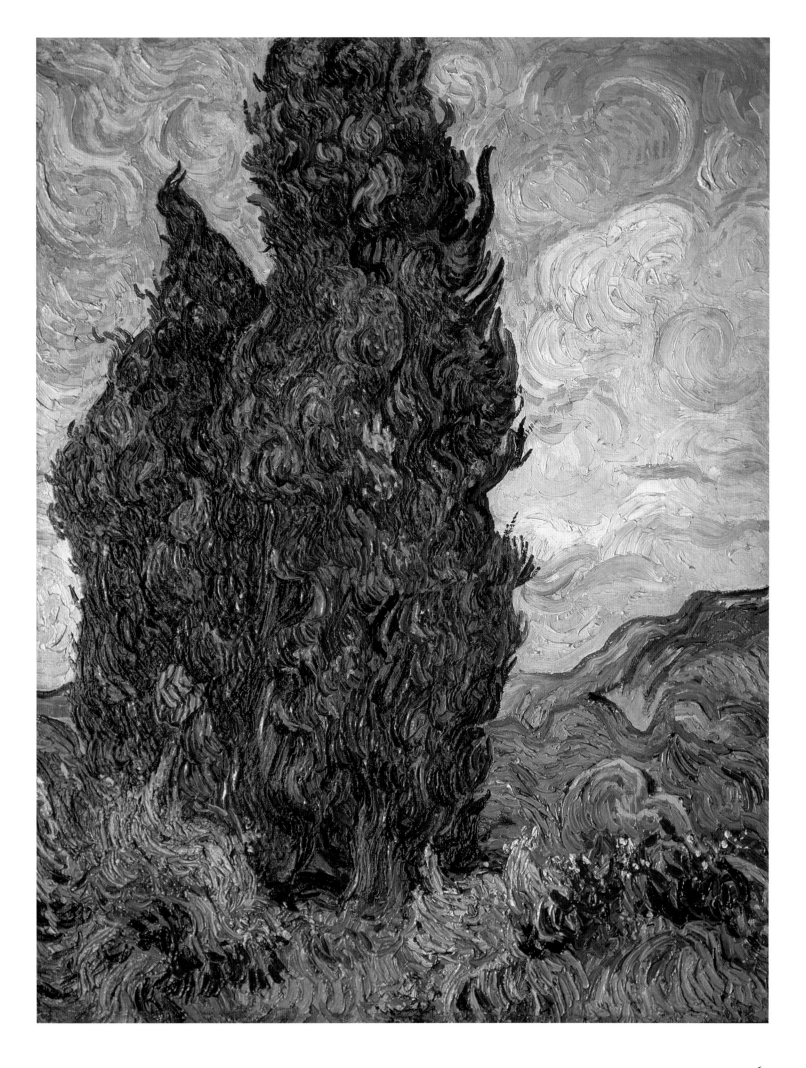

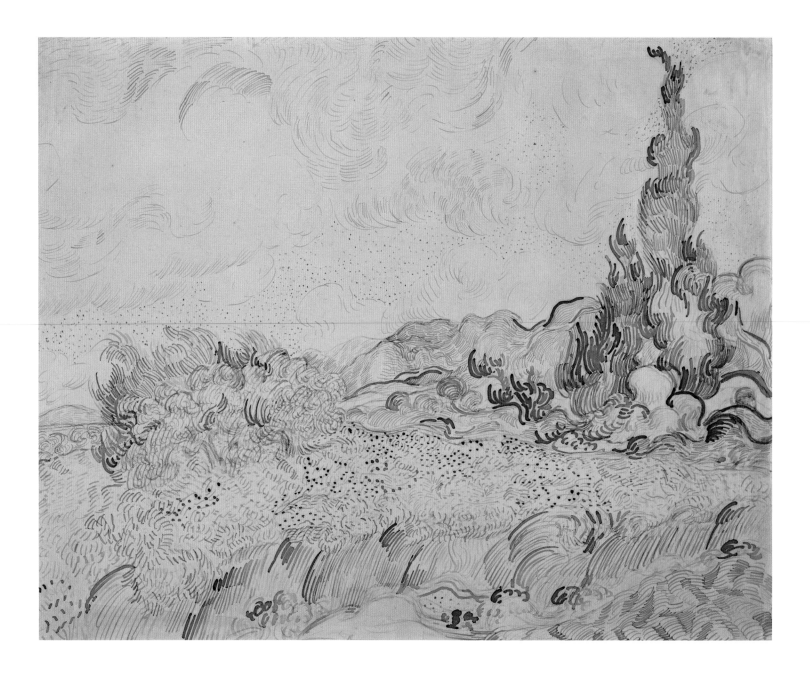

Wheat Field with Cypresses
Saint-Rémy, June 1889
Black chalk and pen, 47 x 62 cm (18½ x 24½ in.)
Van Gogh Museum (Vincent van Gogh
Foundation), Amsterdam

His total dedication to nature can be seen in his painting *Green Wheat Field with Cypress* (p. 66). Here the viewer's gaze is drawn towards the waving greeny-yellow of the ripe wheat field, which flows diagonally across the painting like a great river. The same yellow can be seen in the straw roofs of the houses in the background and also in the cloud formations and the bushes to the top right of the painting. The dark blades of grass in front of the wheat field heighten the movement to the right. Opposite is a massive upright blackish-green cypress pointing upwards – a strong accentuation of colour amidst all the dynamic movement of the painting. Green coloured areas frame the yellow wheat field, against which the light blue of the sky acts as a contrast. This contrast is toned down by the white of the ears of wheat and that of the clouds, so that in spite of the movement one is given the impression of harmony and organized unity.

Colour was still very much a dominant means of expression for van Gogh, yet was no longer the main element in these paintings, as was the case with the paintings completed in Arles; now only a few pictures show large areas of colour or weighty complementary contrasts. The vividness of colour is now transferred to the forms, or to be more exact, to their movement. This is clearly seen in the paintings of cypresses.

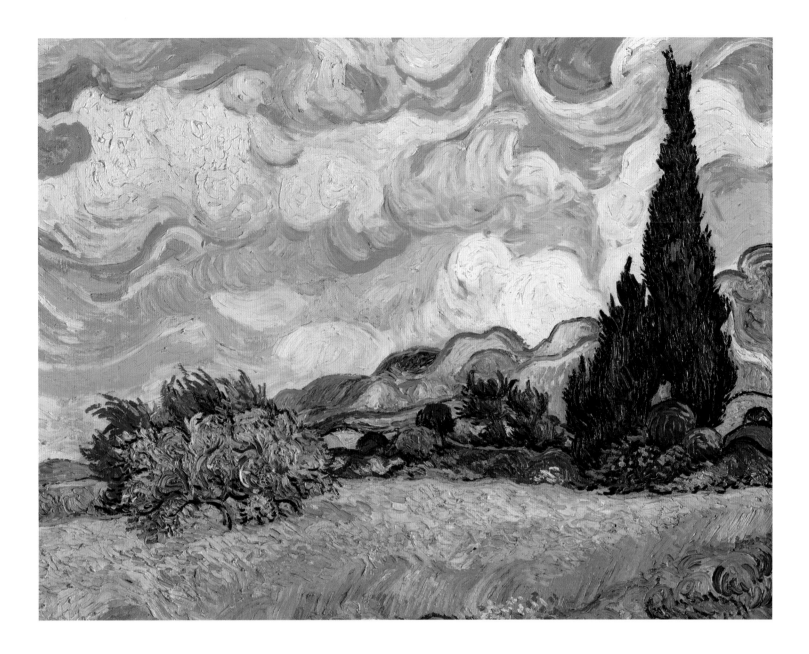

From that point the cypress became his central motif. It appears again in the painting *Wheat Field with Cypresses at the Haute Galline near Eygalières* (above), only here the cypress is pushed to the right-hand side of the painting and appears much darker and longer against the strange colour of the overcast sky – it is the only vertical accent in the picture. The overripe cornfield is wedged between the green areas, surrounded by rising blue cliffs. An ascending diagonal movement leads from the fields over the trees to the hills and from there to the clouds. Their convulsive shapes, only barely indicated here, dominate the whole sky in the later *Starry Night* (p. 71). This painting could almost be subtitled "Calm before the Storm". A feeling of calm pervades the picture, yet a stormy turbulence (created by the brushstrokes) is clearly present.

These evergreen trees become the single theme of the painting *Cypresses* (p. 67), which take up almost the whole of the left side. Painted with flickering strokes of the brush, the trees grow upwards like green flaming tongues, and even the edge of the painting cannot hinder their unbridled growth; the top of the larger tree is cut off. Pure nature, growth and movement, and untamed energy are displayed – a cosmic happening perhaps? A clue to this could be the rising sickle of the moon in the star-lit night. In the summer of 1889 van Gogh

Wheat Field with Cypresses at the Haute Galline near Eygalières
Saint-Rémy, late June 1889
Oil on canvas, 73 x 93.5 cm (28¾ x 36¾ in.)
The Metropolitan Museum of Art, New York

"There are endless corn fields under dull skies, and I've not shied away from portraying this sadness and utter loneliness ... I believe these pictures will tell you what I am not able to express in words – namely that which I view as healthy and inspiring in rural life."

VINCENT VAN GOGH

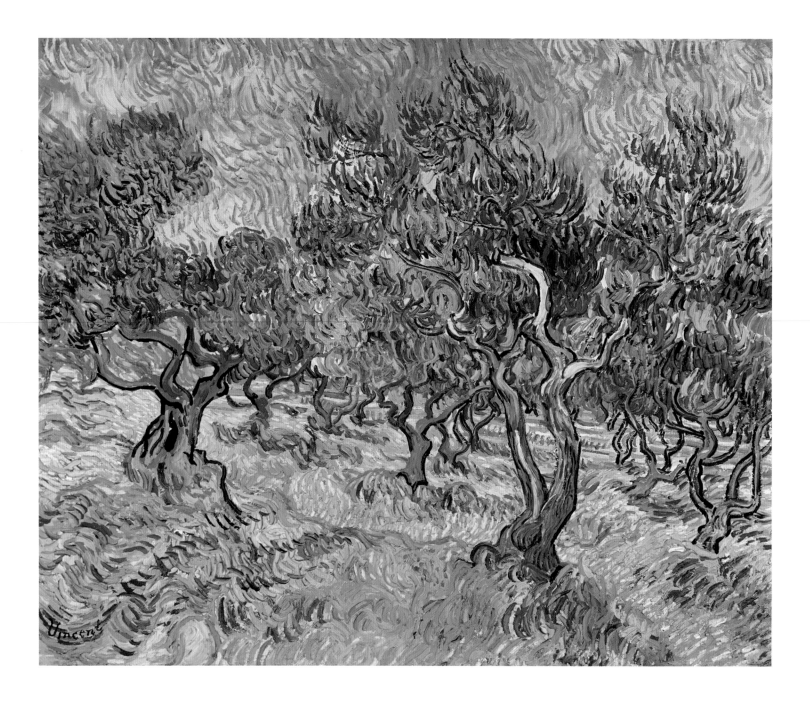

Olive Grove
Saint-Rémy, mid-June 1889
Oil on canvas, 72 x 92 cm (28¼ x 36¼ in.)
Kröller-Müller Museum, Otterlo

"I can tell you from the beginning that everyone will say that I work too quickly. Don't believe it. It is the excitement, the honesty of a man of nature, led by nature's hand. And sometimes this excitement is so strong that one works without noticing it – the strokes of the brush come in quick succession and lead on from one to the next like words in a conversation or letter. Yet one should not forget that it was not always so and that in the future too many despondent days without any inspiration will follow."

VINCENT VAN GOGH

wrote to Theo: "The cypresses constantly occupy my thoughts – I want to paint something similar to my sunflower paintings. It's amazing that nobody has yet painted them as I see them; in their lines and proportions they are as beautiful as Egyptian obelisks. And the green is such a special fine tone."

A much more severe attack in the autumn of 1889 took him by surprise whilst he was working on a painting outside the asylum. Thoughts of suicide and terrible hallucinations, which only very slowly eased off, were followed by a period of deep depression. This relapse clearly reveals the chronic character of his illness. He began to fear his fellow inmates and stayed in his room; for six weeks he did not set foot out of the building. Finally he began to paint again, but only inside the asylum. He wrote to his sister Willemin: "Since my illness I sense a terrible loneliness even in the open air, so that I don't dare to go outside."

This fear became evident in his choice of colour. The earlier vibrant colours of his palette increasingly gave way to toned-down colours and darker harmonies, with nothing left of the stark colour contrasts. This did not mean a return to the tonal harmony of the paintings of his Dutch period; instead this recalled

the chromatic multiplicity of tone which he had discovered in Paris and Arles, and he introduced to this a series of unusual disjointed tones, which corresponded to his state of mind. Again he uses the tree theme in the painting *Olive Grove* (opposite), but quite differently from the cypress paintings. Here one single movement runs through the whole of the painting's surface. Soil, trees and sky display the same wavy strokes of the brush, and so the separate unities are brought into one complete entity. The three larger areas of colour – ochre, green and blue – are more reserved and soft, and the colour contrasts are also toned down. The strong lines of the branches blend in with the arabesque pattern of the softer areas of the sky, just as the blue of the sky is turned in on the leaves and stems, whose green and grey tones blend in with the soil – everything is brought into one single harmony. A calming effect is also gained by the equilibrium between cold and warm colours, establishing an almost dreamlike unreality. By using black contours the strange silhouette of the olive tree trunks, which are bent and twisted as if in pain, are marked out. A mute pain appears to pervade this nature and restlessness runs through the whole.

In Saint-Rémy van Gogh discovered true movement in his work. In his paintings created here and later in Auvers, two clearly marked styles are seen, which are elaborated to their outermost limits – on the one hand a continuous

"I put my heart and soul into my work, and have half lost my mind in the process."
VINCENT VAN GOGH

Starry Night
Saint-Rémy, June 1889
Oil on canvas, 73.7 x 92.1 cm (29 x 36¼ in.)
The Museum of Modern Art, New York

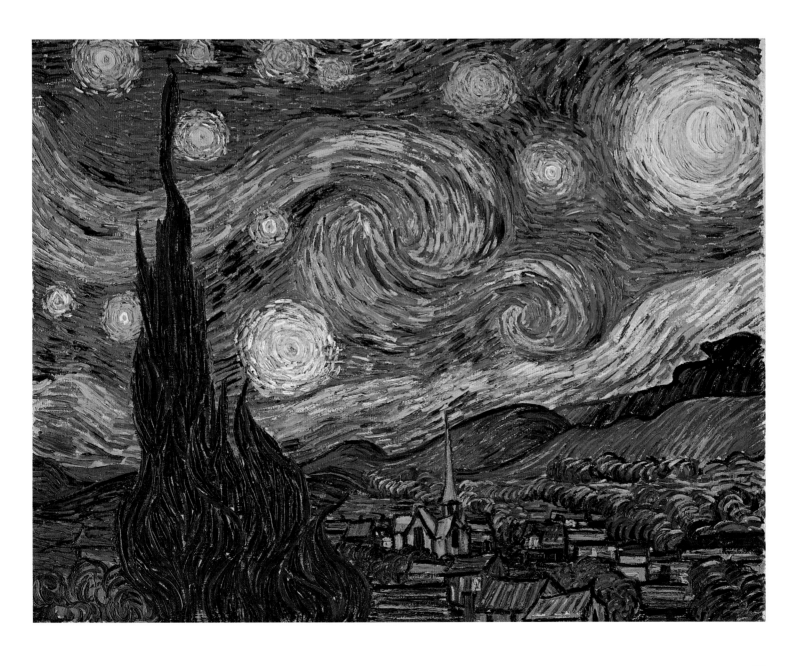

composition of winding, wavy curves, on the other a complicated hatching of short, sharp dashes. Both elements are loaded with excitement and dynamic forms, clearly elements of a style of painting born out of excitement and tension.

Both linear forms are combined in *Starry Night* (p. 71), one of his major works and at the same time one of his strangest. Once again he seized upon the theme of his night paintings from his earlier periods in Paris and Arles, but now in a totally different context. It is one of the few works which completely avoids a direct observation of nature, with colours and forms coming from his imagination in order to evoke a particular atmosphere. A highly dramatic cosmic event is taking place in the sky. Two gigantic spiral nebulae are entwined; eleven enormously enlarged stars with their aureoles of light break through the night; an unreal orange-coloured moon looks as if it is joined to the sun; a broad band of light – perhaps the Milky Way – is drawn across the horizon, and the deep blue sky appears to be in staggering turmoil. The immediacy and expressive powers of the painting are strengthened by the impulsive, sweeping flood of brushstrokes.

Yet van Gogh does not yield passively to this exciting vision. By artistic means he handles this vision in a different manner in his choice of contrasting elements to portray the events on this earth and so enhance the effect. The sleeping town in the foreground, which is portrayed with short, straight strokes of the brush, contrasts with the curving shapes in the sky; even the small yellow lights of the houses present a contrast to the stars in their quadrangular or rectangular shape. The pointed towering church spire – reminiscent of the north – cuts across the earth's horizon, just like the blazing flames of the powerful cypresses: a vertical, earthbound contrast to the circling star nebulae in the sky.

This contrast can be viewed as opposing powers: human striving and effort ("reaching for the stars") against celestial, cosmic powers, since the actual event in the painting does not take place on earth but in the heavens. In this picture, perhaps an apocalyptic vision, van Gogh tries to free himself from overpowering emotions. It must also be seen as an attempt to express pictorially his desire for the infinite in nature.

Three months later, in September 1889, he painted his last self-portrait (opposite). In this half-length picture the artist stands in a three-quarter profile against a blue-green-grey spiraled, whirling, rhythmic background. The suit, over the collarless white shirt, is almost the same colour, in sharp contrast to his strained facial expression and the dark, fixed eyes – "a look which goes straight through one" (Antonin Artaud).

The pulsating forms of the background, the sense of excitement captured in the picture, are not determined by a set rhythm or a rigid pattern; they convey

OPPOSITE:
Self-Portrait
Saint-Rémy, September 1889
Oil on canvas, 65 x 54 cm (25½ x 21¼ in.)
Musée d'Orsay, Paris

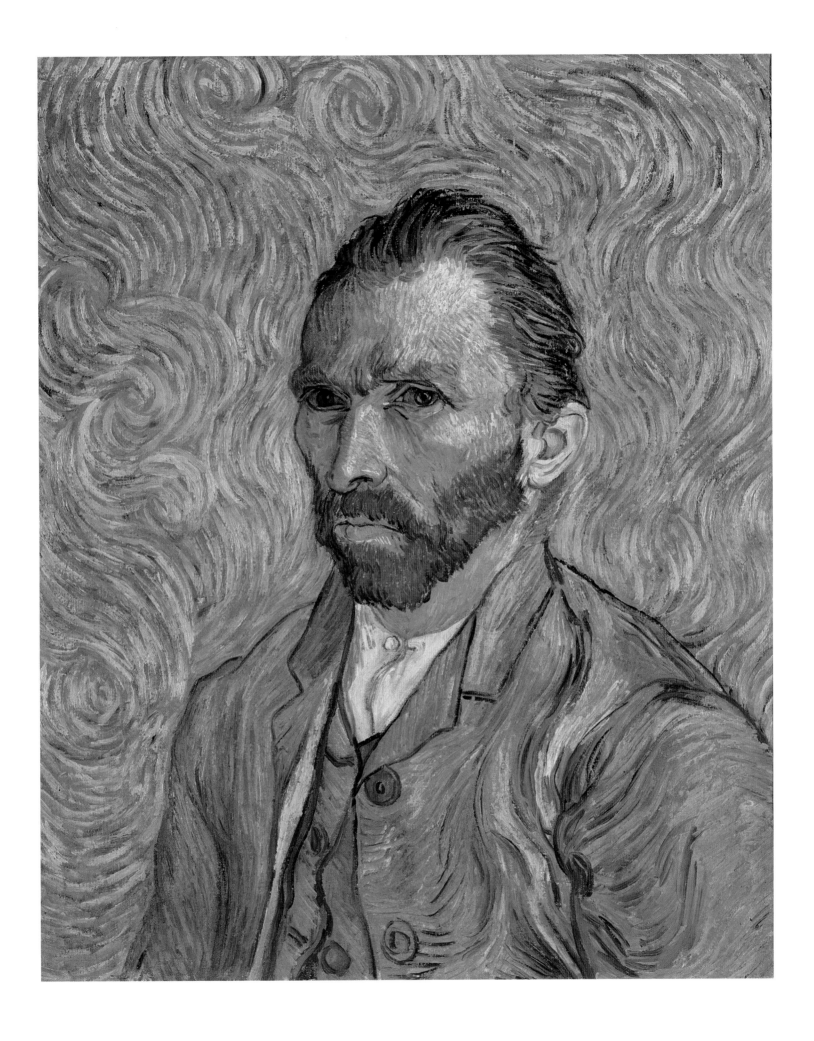

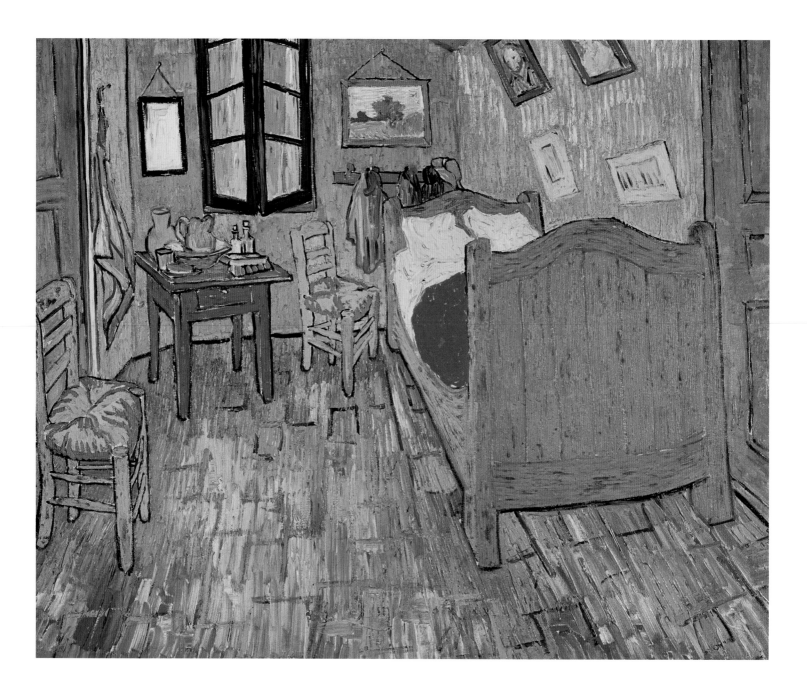

Vincent's Bedroom in Arles
Saint-Rémy, early September 1889
Oil on canvas, 73.6 x 92.3 cm (30 x 36¼ in.)
The Art Institute of Chicago, Chicago

"This time it's quite simply my bedroom – here colour is everything; objects are given a greater style by simplifying them, thereby giving the impression of peace and general sleep. Simply stated, the picture should stir the head, or more properly, the fantasy."

VINCENT VAN GOGH

much more the overwhelming surge of his feelings towards his environment. Yet these emotions are held spell-bound in fixed forms and are integrated as direct chosen elements of movement in a controlled composition. In spite of all the flowing unrest, a great balance is dominant.

Towards the end of that fateful year of 1889 the artist's inspiration appears to have dwindled. In the evenings he was often bored to tears in the asylum, despite the fact that he read a lot. Since he was no longer able to paint in the open air, he made copies or replicas of his own earlier paintings. Paintings such as *Vincent's Bedroom in Arles* (above) were either for his mother or his sister. He had previously taken up this motif shortly before Gauguin's arrival in Arles, but the first version was damaged during transportation. In Saint-Rémy he painted a copy of it from memory and this one is the most brilliantly coloured of the three versions of this theme. He wrote of it: "This time it's simply my bedroom, only the colours should work here, and through the simplification which gives the things a larger style, peace or complete sleep ought to be suggested."

In spite of van Gogh's intentions the picture does not give the impression of total calm. The objects do not relate to one another; each one is isolated. To add

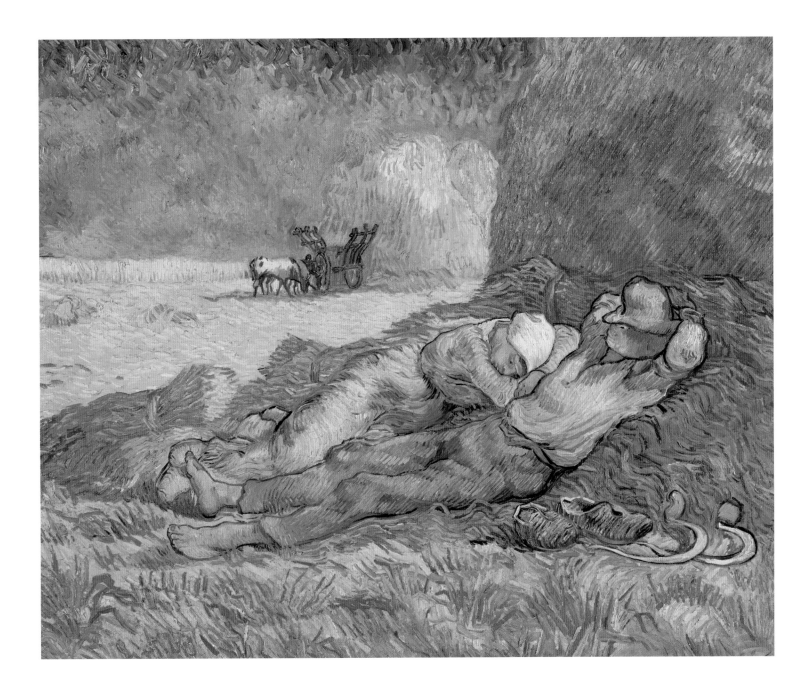

to the uneasy feeling we have in observing the painting, all the objects have been considerably foreshortened; the floorboards lurch steeply forward, giving the impression of almost lifting over each other, the window is half open, the slanting furniture – wash table and chairs near the bed – as well as the paintings hang over into the room. The ambivalent atmosphere lends the picture a strange, tense aura: it is the wish for cosiness, for a home, for comfort and care, which contradicts reality. Desolation, loneliness and homelessness are stronger than the desire.

In winter 1889 the number of his landscape paintings decreased; his work indoors showed a concentration on the reproduction of his earlier sketches and of sketches made by other artists. Using black-and-white lithographs, reproductions and woodcuts which Theo had sent him from Paris, he transformed the works of Rembrandt, Delacroix and Millet into colour paintings. Above all, the monumental simplicity of Millet's peasant figures had always influenced him. Between the autumn of 1889 and spring 1890 he painted no fewer than 23 mostly, "how effective the *Field Workers* [Millet] becomes through the use of colour."

This amazing effect of colour on a copy of Millet's work can best be seen in *Noon: Rest from Work* (above). Almost two-thirds of the painting is taken up by

Noon: Rest from Work (after Millet)
Saint-Rémy, January 1890
Oil on canvas, 73 x 91 cm (28¾ x 35¾ in.)
Musée d'Orsay, Paris

"I have drawn into myself so much that I literally do not see any other people any more – excepting the peasants with whom I have direct contact, since I paint them."

VINCENT VAN GOGH

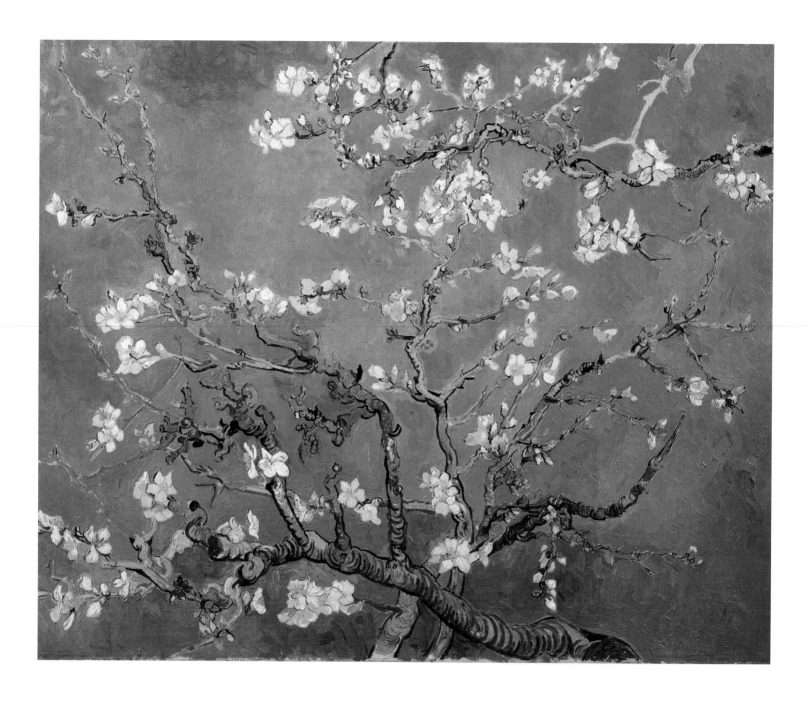

Almond Blossom
Saint-Rémy, February 1890
Oil on canvas, 73.5 x 92 cm (30 x 36¼ in.)
Van Gogh Museum (Vincent van Gogh
Foundation), Amsterdam

"My work has gone well – the last painting was of branches in bloom. You will see that I painted this picture most patiently and skilfully, in utter peace and quiet, with the greatest certainty of brush strokes."

VINCENT VAN GOGH

the gold-yellow-orange of the cut, tied and stacked hay. A strong contrast in colour is provided by the light blue of the sky, which is echoed in the blue clothing of the peasants sleeping in the shade. Stretched out, they are seeking protection from the blazing midday heat, and in their sleep appear to be at one with nature. Earth and sky, man and nature form one single unit belonging together.

The most intensive, radiant and clearest blue sky that van Gogh ever painted can be seen in the background of the painting *Almond Blossom* (above), which was conceived as a christening present for his little nephew, who was born at the end of January 1890 and given his uncle's name, Vincent. The glowing white almond blossoms break forth from the still-wintery branches and, heralding spring, they proclaim the beginning of a new life. In this painting Vincent practised patience and self-discipline, which was something totally alien to his work. He perhaps restrained himself too much since during his work on this painting, his last from Saint-Rémy, he became ill.

In January and February 1890 more exciting things happened than the birth of his nephew and his being called after Vincent: for the first time an extensive

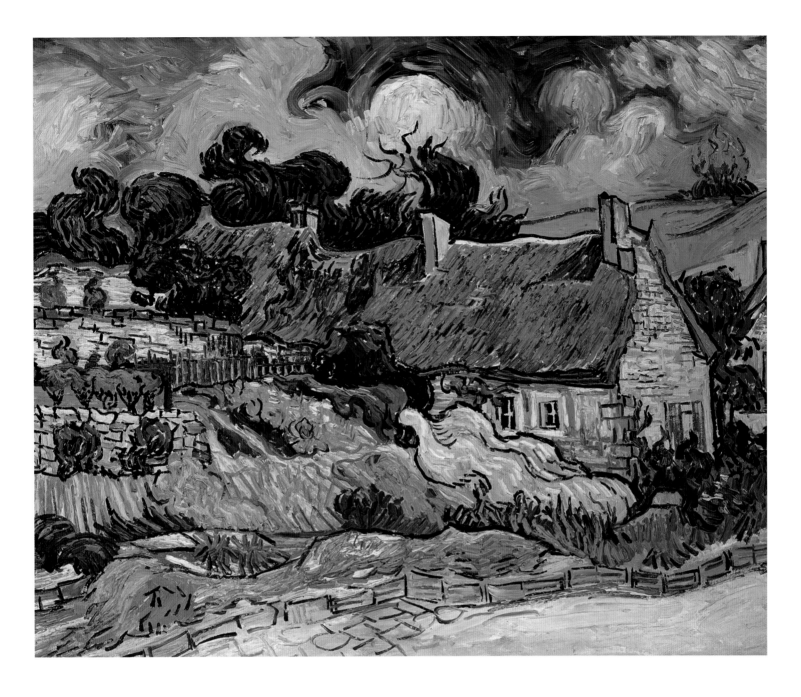

article was written about him in an art magazine. The exhibition of the Brussels group "Les XX" was opened in Paris, where van Gogh showed a few of his paintings; at the same time, the new Salon des Artistes Indépendants was being prepared for March, in which he was also to take part. Finally he received news of the sale of his painting *Red Vineyard* in Brussels for 400 francs to Anna Boch, the sister of the poet Eugène Boch. It was one of the few paintings which Vincent was able to sell during his lifetime, though not, as rumour has it, the only one.

The events of the last weeks proved too much for him. He suffered a new attack, which lasted longer than the other ones, almost two months. Again he suffered from derangement, fear of death and shocks, accompanied by hallucinations and fits of rage. Only after several weeks had gone by did he venture to write to say that he had decided once and for all to leave the asylum. After making a short trip to Paris to visit Theo and his family he travelled in May 1890 to Auvers-sur-Oise near Paris, where the doctor and amateur painter Dr Gachet had agreed to look after him. He rented a room in the Ravoux Inn opposite the small town hall, and immediately began to paint again, making use of the new motifs which the place and surroundings offered him.

Thatched Cottages at Cordeville
Auvers-sur-Oise, June 1890
Oil on canvas, 72 x 91 cm (28¼ x 35¾ in.)
Musée d'Orsay, Paris

"And I could feel a heart in all of it, the soul who had made all of it and who himself had answered the most terrible doubts with this vision, who could feel, know, understand and enjoy the highs and the lows, exterior and interior, one and all in a thousandth of a part in time – all this I could feel when I write the words ..."
HUGO VON HOFMANNSTHAL,
letter of 26th May 1901

OPPOSITE:
Country Road in Provence by Night
Saint-Rémy, May 1890
Oil on canvas, 92 x 73 cm (36¼ x 28¾ in.)
Kröller-Müller Museum, Otterlo

The painting *Thatched Cottages at Cordeville* (p. 77) bears witness to his renewed vital creativity, although it appears to have been painted more fleetingly than ever. A lot of things in the painting are only vaguely shown; open forms and contours and loose strokes of the brush lead one to conclude that the painting was done in a hurry. Despite the idyllic motif of the old, thatched roofs of the farmhouses with vegetable garden, fence and wall, a great unrest is spread over the whole of the painting by the bushes and dark trees.

A nervous energy appeared to have taken hold of the artist again. The linear elements of his paintings are stressed and dominate the dark, earth-coloured palette. This is obvious in the work *Country Road in Provence by Night* (opposite). The distinct brushstrokes, so marked in all of van Gogh's works, now become a torrent, an avalanche, which pours over the whole of the canvas. Now the actual brushstrokes take prominence just as the colours did in Arles. Objects have lost their stable form, their outlines have been extended lengthways, and they wind about and coil in on themselves. These connect the motif, consisting of many tiny streaming parts which follow the movement of the outline. Their colours are disjointed and dull – the colour energy is transferred to the lines of energy, which appear as different centres of power, penetrating and struggling for dominance like magnetic fields which both attract and repel one another.

In this way the real landscape takes on an almost celestial character, also called up by the central ordering of the dark cypresses, which dominate the whole picture, placed between sun and moon with their wide halos of light. Two fully grown trees intertwining with one another try with all their might to reach upwards. The ground is full of similar forms, with the yellow field, the sloping stream of the road and the flat blue range of mountains in the background, which are reflected in the green blades of grass on the edge of the road. As a stark contrast to all this movement are the two figures on the road, the horse pulling the yellow carriage and the house lit up on the right-hand side of the picture. In each area the brushstrokes take on a special character: concentrated in the sky, parallel, interweaving and converging on the ground, flame-like tongues of the intertwining trees extending upwards. Everything in the picture is transformed into a pulsating rigidity.

During these weeks it was only when working that van Gogh could forget about his illness. Painting was not only a therapy for him, it was his whole life. During the seventy days he spent in Auvers, he painted as if possessed. More than eighty pictures were created in this period, amongst them the masterpiece *The Church at Auvers* (p. 62). The clearly delineated form of the church gives the impression of it being a compact sculpture, which forms an organic unit with

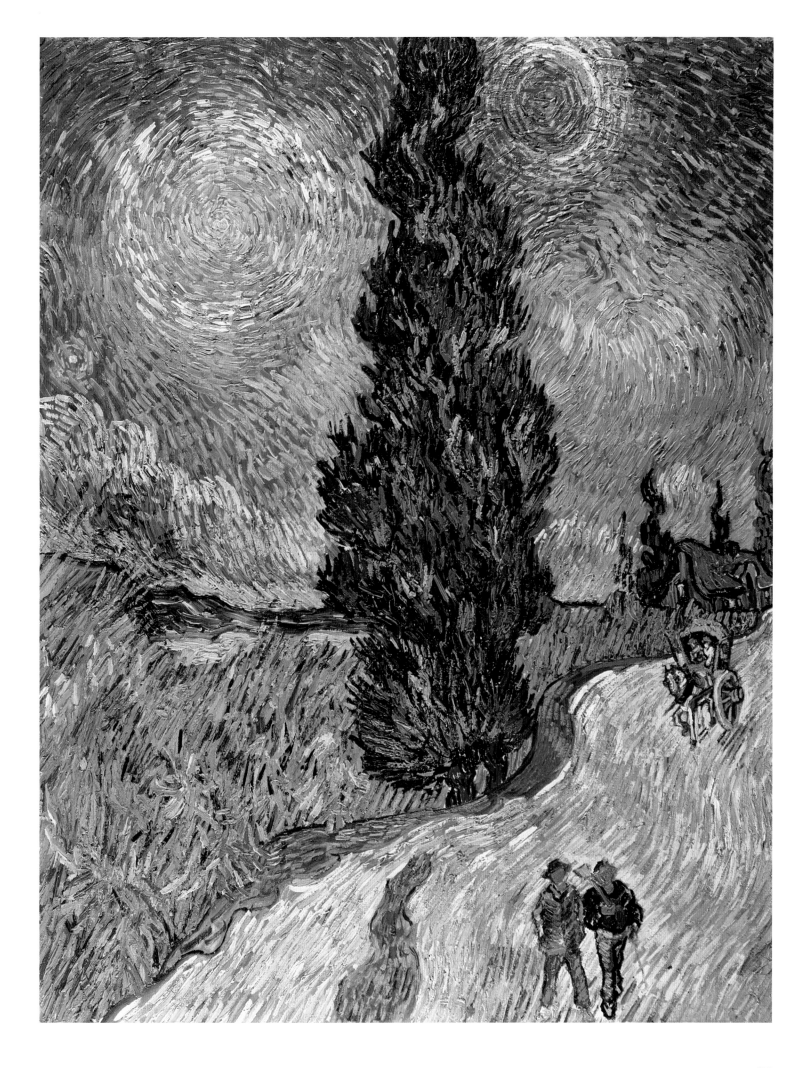

nature. The cobalt-blue sky is a colour of the night, the whole scene appears dark
and the light unreal. A similar darker sky with the same effect of light appears in
the later work *Wheat Field with Crows* (pp. 86–87), with the V-shaped division
in the foreground which has the effect of widening the space.

Already in Saint-Rémy van Gogh had often been preoccupied with religious
thoughts and he had painted some biblical themes. His own religious beliefs for-
bade him from creating biblical figures from his imagination; he did not dare to do
this, and so he looked to the Old Masters for his models. The choice of themes
alone reveals the motif for his religious paintings: he depicted the dead Christ in
the arms of his mother, the raising of Lazarus, to whom he gave his own features,
and the good Samaritan – all suffering figures, who hope for future redemption.

The Good Samaritan (opposite) was modelled on Delacroix' *Pièta*. Delacroix,
like Millet, was both his patron-saint of art and the founder of colour tech-
niques. The reticent wealth of colour in this picture is meant to remind viewers
of his great master. The brighter colours, the characteristic blue and red of
Delacroix, are placed in an environment of more neutral, brownish tones, which
are cleverly connected to one another in graded intervals of warm and cold, light
and dark tones. Van Gogh adds a stream of parallel brushstrokes to Delacroix'
original rhythm in his dynamic sketch. The arabesque forms and winding curves
of the Delacroix painting are transferred by van Gogh into disjointed linear strokes
– a devoted "translation" of the old work into a "modern" pictorial language.

But most of all, even more so than the religious pictures and landscapes, van
Gogh was occupied with portrait painting – that is, the modern portrait. His
models were always the simple, ordinary people around him. It was not for an
external beauty or a certain character trait that he painted these people, but
because of their mere humanity. Although brought to the front of the painting,
they still have something mysterious and unusual about them. The smooth love-
liness of his previous portrait paintings was now totally abandoned. The face
took on a landscape-like appearance, due to the coarse texture of the paint, and
the skin took on a tougher, yet natural constitution.

The composition *Young Peasant Woman with Straw Hat Sitting in the Wheat*
(p. 83) is typical of this. The three-quarter-length figure of the young peasant girl
sits somewhat stiff and bashful amongst the high sheaves of corn, her cheeks
glowing in the same red as the poppies. The pure blue of her blouse, inlaid with
tiny orange spots, contrasts with the warm tones of the corn and her apron, as
well as the golden yellow of her hat and the orange-coloured shadow cast by it.
Once again we can see traces of the realism and coarseness of his earlier brown-
toned peasant pictures.

OPPOSITE:
The Good Samaritan
(after Delacroix)
Saint-Rémy, May 1890
Oil on canvas, 73 x 60 cm (28¾ x 23½ in.)
Kröller-Müller Museum, Otterlo

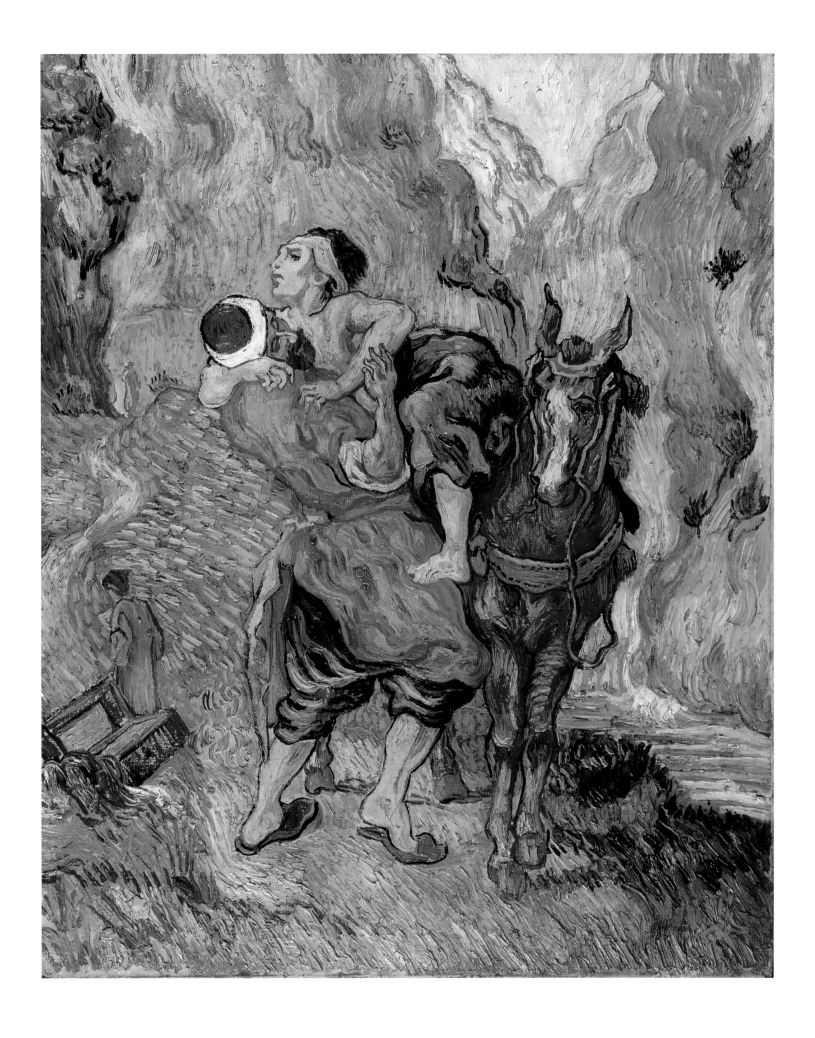

In spite of this, this portrait remains in the shadow of his uncontested masterpiece of portrait painting – his *Portrait of Doctor Gachet* (p. 85). This strange eccentric personality, who himself was a painter and friends with a lot of Impressionist painters, had deeply influenced van Gogh. Melancholy, sadness and resignation, which can be read in Gachet's face – a "despairing expression of our time" – pervade and set the tone of the whole painting. All lines and colours are adapted to this melancholy atmosphere and form an original unity. The lines mainly follow the depressive tendency of the figure, betraying the mood of this sensitive, simple man. The background lines correspond to those of the cap, face and shoulders. Thanks to the ultramarine blue of his jacket, the figure's face is highlighted and becomes paler at the same time. His woeful, pale-blue eyes gaze into the distance. A continuum of pale to dark blue – in the sky, background hills and suit – dominates the whole picture and is to be found again in the flower and the doctor's pupils.

The foundation was laid for a great friendship between the two men, not least because of this portrait. Gachet liked it so much that he asked van Gogh to paint a second version. Art was a strong bond in their friendship and van Gogh was overjoyed to be able, at long last, to paint someone who really understood his work. After such a long period of loneliness he had finally found a person with whom he could discuss his paintings.

Yet Vincent's artistic happiness was not to be long-lived. Things were not going well for his beloved brother Theo, whose financial and moral support Vincent needed to be able to survive. Theo's child was seriously ill, his wife was totally exhausted from endless sleepless nights, and often disputes arose between himself and the gallery owners, who no longer had faith in his artistic judgement. Greatly worried about his brother, Vincent travelled to Paris in July. Theo's difficulties also threatened his own existence, and his nerves began to suffer, so he did not stay the whole length of his time there. From Auvers he wrote to Theo: "After my return here I am still very sad and the misfortunes, which are threatening you, lie heavy on my heart ... my very steps are uncertain. I am afraid I'm a great burden to you, since I'm living from your financial help."

On top of this he also fell out with Gachet. He explained to his brother: "In my opinion I don't think we can rely on Dr Gachet at all. I get the impression that he is more ill than myself, or let's say at least just as ill. If a blind man leads the blind, don't they then both fall by the wayside?"

This disagreement with Gachet must have deeply upset him. Even here in his new surroundings, complete and utter loneliness threatened him again. Yet he did not in any way attempt to avoid this threatening loneliness. He worked

OPPOSITE:
Young Peasant Woman with Straw Hat Sitting in the Wheat
Auvers-sur-Oise, late June 1890
Oil on canvas, 92 x 73 cm (36¼ x 28¾ in.)
Private collection

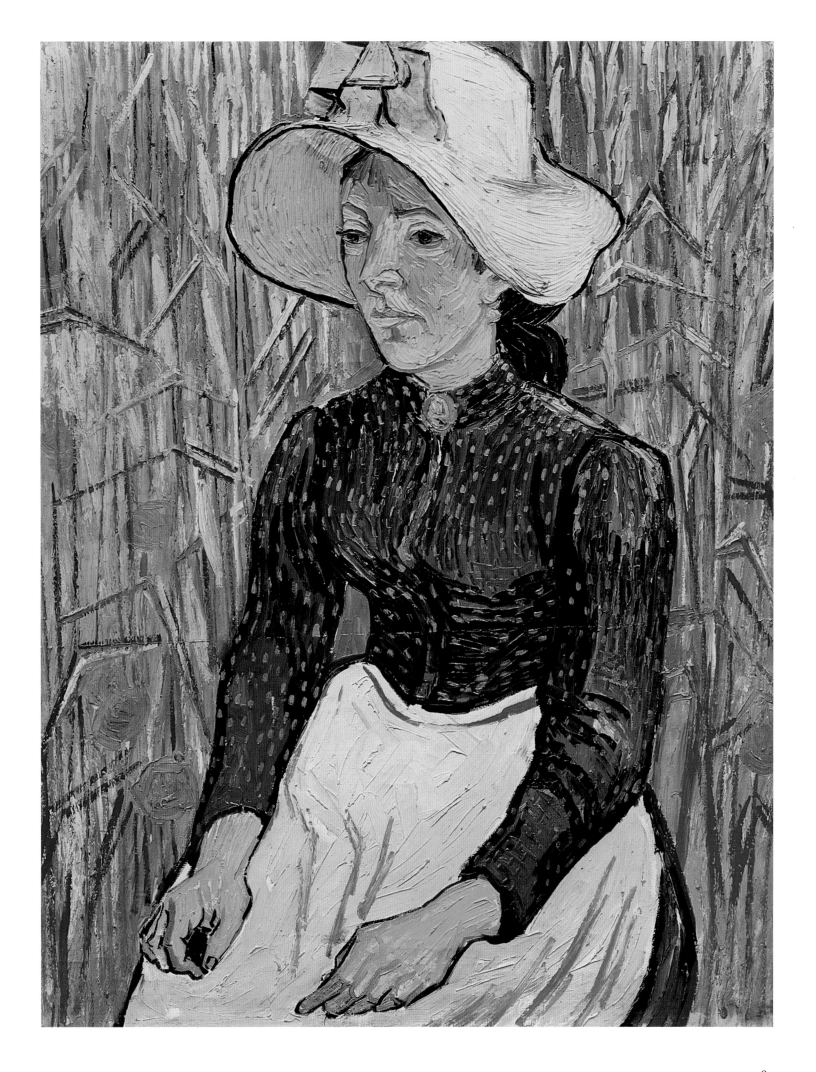

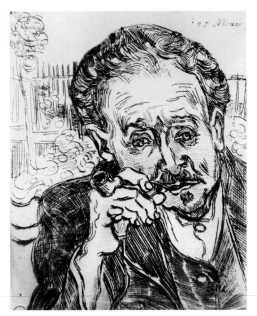

Portrait of Doctor Gachet: L'Homme à la Pipe
Auvers-sur-Oise, May 1890
Etching, 18 x 15 cm (7 x 6 in.)

"Mr Gachet seems to me to be just as ill and as nervous as you and I, as well as being much older. He lost his wife a few years ago. But he's a doctor, nevertheless, that's what keeps him going – this manual skill and belief. We're quite good friends already. I'm working on his portrait – his head is covered by a white cap; his blond hair I've painted in really light tones; the colour of the skin on his hands is also really fair; a blue jacket; the background a cobalt blue. He props himself up against a red table on which a yellow book and foxglove with purplish flowers stand."

VINCENT VAN GOGH

OPPOSITE:
Portrait of Doctor Gachet
Auvers-sur-Oise, June 1890
Oil on canvas, 67 x 56 cm (26¼ x 22 in.)
Private collection

all the more on his own, since Gachet had completely stopped all his visits and invitations.

His work was the only thing that kept him alive. Often he painted to near exhaustion, producing a new painting every day, sometimes even two. One month before his death he painted *Wheat Field with Crows* (pp. 86–87), which clearly echoed his mood during those days. In this painting he attempted to convey his "sadness and extreme loneliness". The expanse of the field is conveyed by the unusually wide format of the picture, which opens up into three diverging parts in the foreground. The observer is unsettled by not knowing where both the horizon and the path end, whether in the field or off the edge of the painting somewhere. The normal structural perspective of the wide-open fields is turned upside down – its lines of alignment run from the horizon to meet in the front of the painting. The space presented here has no perspectual centre to it any more. The blue sky and the yellow fields push forcibly away from one another, and a flock of crows crosses the boundaries to the uncertain fore-edge.

In contrast to his more turbulent paintings, the whole space in this one is filled with a succinct breadth and simplicity. The colour palette is reduced to the three basic colours and one complementary colour – the blue of the sky, the yellow of the corn, the red of the separating paths and the complementary green of the blades of grass along these paths – thus creating an overall image of control. The predominant horizontal line is determined by the artist's state of mind rather than from the frame or canvas. It neither presents a panorama, nor is it created by the things that dominate the space, so that there are barely any vertical values. In all, parts and whole, closeness and distance cannot be definitely distinguished from one another.

Many believe this picture to be one of his last, because of his absolutely valid formulation of the theme of a landscape, which appears to reflect the original laws of creation. However, a dozen more followed, amongst them *Thatched Sandstone Cottages in Chaponval* (p. 89). Yet the power and quality of the *Wheat Field with Crows* is never attained again, so it is quite valid to say that this painting is one of the most complete testimonies to his art form.

Vincent's last, unfinished letter to Theo on 27th July 1890 sounds like a farewell: "I would really like to write to you about a lot of things, yet I feel this is useless ... In my own work I put my whole life in jeopardy, and I have half lost my mind in the process ... I repeat to you again that I have always looked upon you as something different than an ordinary art dealer ..."

Without his brother, who had supported him all his life, Vincent would not have had the means to paint such pictures. Yet now his life support was himself in great difficulty, and Vincent's further existence was therefore thrown into question. The catastrophe appeared unavoidable. His relationship with Dr Gachet had come to a final end. All his contacts with his environment were destroyed and with this the hope of work, which had up until now kept him alive. In the end the continually recurring attacks sounded the alarm for his final madness.

His situation was hopeless – van Gogh had failed totally in life. Yet one option still remained. On the evening of 27th July 1890 he went at dusk into the fields and shot himself in the chest with a revolver. With all his strength he managed to drag himself back to the inn where he died two days later in the arms of his brother, who had hurried to his side.

This marked the end of the singular life of an artist who defies comparison with any other. In his art, which he had arduously wrestled with and which he finally paid for with his life, van Gogh dared a synthesis such as hardly any

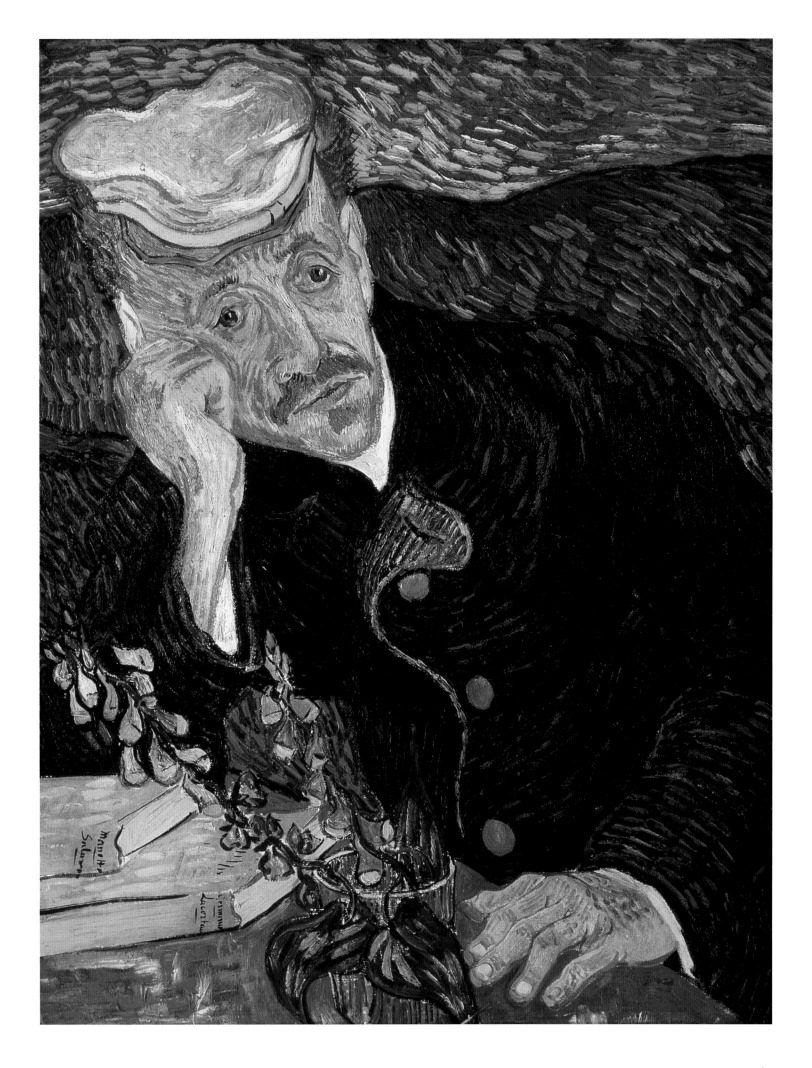

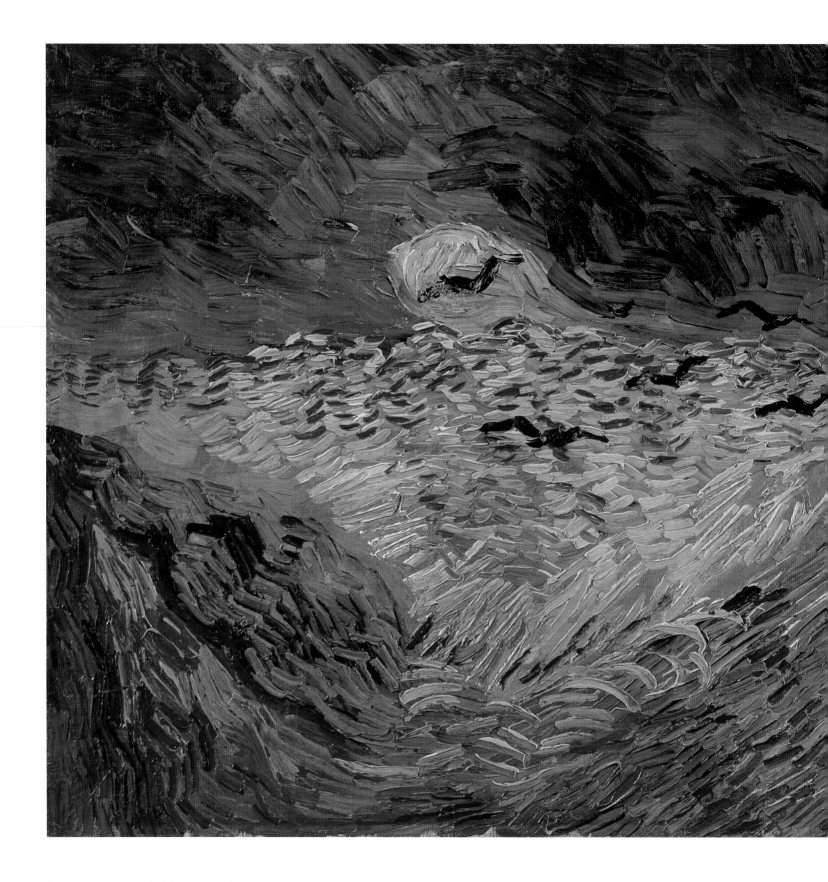

"I experience a period of frightening clarity in
those moments when nature is so beautiful. I
am no longer sure of myself, and the paintings
appear as in a dream."

VINCENT VAN GOGH

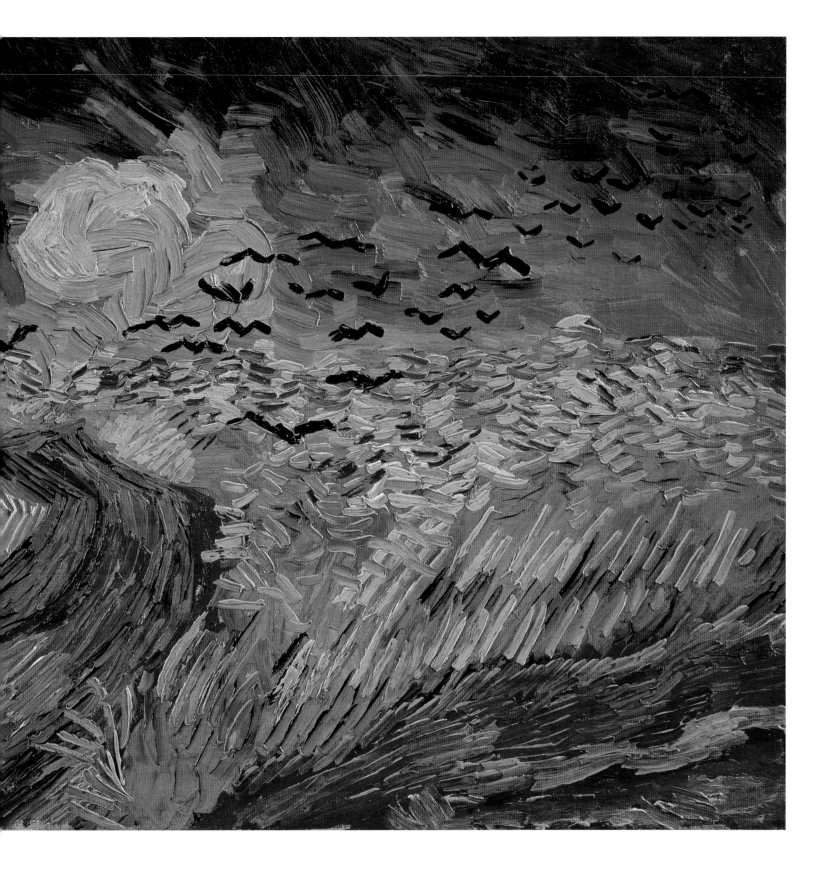

Wheat Field with Crows
Auvers-sur-Oise, July 1890
Oil on canvas, 50.5 x 103 cm (20 x 40½ in.)
Van Gogh Museum (Vincent van Gogh
Foundation), Amsterdam

artist has dared since. Art and life became an inseparable unit to him, and with this he realized an ancient artistic dream of reality. To create works of art meant no less to him than to paint life – not mere reality, but the principle of life.

Van Gogh had not only developed the three fundamental elements of painting – colour, line and composition – into further artistic elements of style, but also endowed them with a new and unique significance: colours as the breath of life, which grants all things life; the line as a principle of movement, as the dynamics of life and as indestructible energy; the composition as a place in which to express his view of the world. Fulfillment and loneliness, desire and doubt, love and destruction, devotion and flight from reality, closeness and distance, duration and transistoriness – all these things, one person, an artist, painted in his work.

He sought consolation in his art from the world and life, which he loved but whose love was not returned. He suffered in this world and was destroyed by it. With his art he created his own new world, which was full of colour and movement and contained everything he knew about existence.

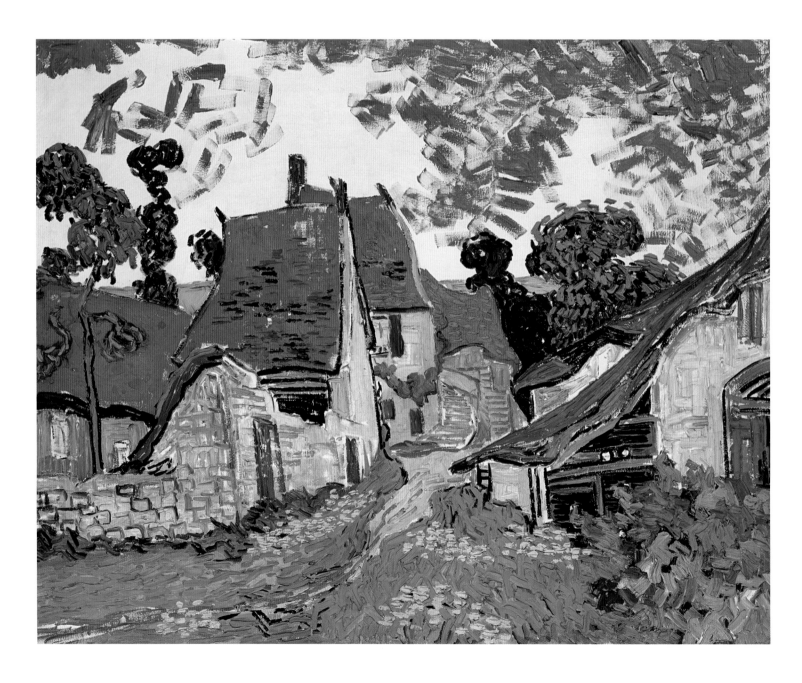

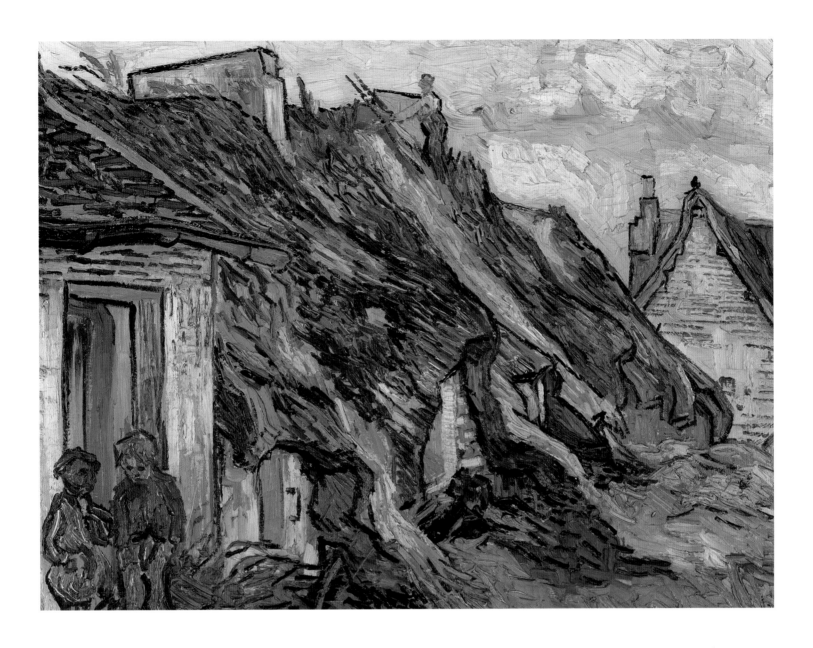

Thatched Sandstone Cottages in Chaponval
Auvers-sur-Oise, July 1890
Oil on canvas, 65 x 81 cm (25½ x 32 in.)
Kunsthaus Zürich, Zurich

OPPOSITE:
Village Street in Auvers
Auvers-sur-Oise, May 1890
Oil on canvas, 73 x 92 cm (28¾ x 36¼ in.)
Ateneumin Taidemuseo

Vincent van Gogh 1853–1890:
Life and Work

1853 Vincent Willem van Gogh, born on 30th March in the Dutch village vicarage of Groot-Zundert (North Brabant), the first of six children to Theodorus van Gogh (1822–1885), a preacher in the Dutch Reformed Church, and his wife Anne Cornelia, née Carbentus (1819–1907), the daughter of a bookbinder from The Hague. He is named after the still-born child who died on this very day the previous year.

1857 Birth of his brother Theodorus, called Theo.

1861–1864 Attends the village school in Zundert.

1864 Enrolls in the private boarding school in Zevenbergen. Learns French, English and German, practises drawing.

1866–1868 Attends the boarding school in Tilburg.

1868 Gives up school and goes back to Groot-Zundert.

1869 Goes to The Hague where he enters the branch office of the Paris art dealer Goupil & Cie, founded originally by his uncle Vincent. Under the supervision of H. G. Tersteeg he sells reproductions of works of art; reads extensively and visits museums.

1871 His father is relocated to a new post as a vicar at Helvoirt in Brabant, where he moves with his family.

1872 Spends his holidays at his parents' and then visits his brother in The Hague. This marks the beginning of the extensive exchange of letters between them.

1873 JANUARY: Is transferred on the initiative of his uncle to the Brussels branch of Goupil.
MAY: Transfer to the London branch. Before his departure he travels to Paris, which impresses him deeply; visits the Louvre.
JUNE: Works for a year with Goupil in London. On his walks he makes his first sketches, which he throws away. Falls in love with Ursula, the

daughter of his landlady. Her rejection of his love precipitates a personal crisis.
NOVEMBER: His brother Theo is transferred to the Goupil branch in The Hague.

1874 SUMMER: Spends his holidays with his parents in Helvoirt and confides in them his private disappointment to explain his depressive mood. Goes back to London together with his sister Anna in the middle of July. Leads a lonely life and shows little interest in his work; reads a lot, especially religious writings.
OCTOBER-DECEMBER: His uncle makes him transfer temporarily to the main office of Goupil in Paris, hoping this change of environment will improve his situation.

1875 MAY: Final transfer to Paris. Continues to neglect his work, much to the annoyance of his colleagues and clients alike; visits museums and galleries, is enthusiastic about Corot and the 17th-century Dutch School of painting.

Vincent's father Theodorus Van Gogh. Drawing by Vincent van Gogh, Etten, July 1887. Pen-and-ink, washed 33 x 25 cm (13 x 10 in.) Private ownership, The Hague

Vincent's brother Theo, around 1888–1890

Vincent at the age of 13 in the year 1866. This picture was probably taken after he finished boarding-school in Zevenbergen and before he entered the secondary school in Tilburg.

OCTOBER: Father Theodorus is relocated to Etten, near Breda.

DECEMBER: Without having applied for leave beforehand, he spends Christmas with his parents.

1876 APRIL: Hands in his notice at Goupil's. Goes to Ramsgate, near London, and works as a supply teacher, receiving only board and lodgings.

JULY-DECEMBER: Continues to work as a supply teacher in Isleworth, a working-class area on the outskirts of London. Afterwards he works as an apprentice lay preacher and teacher together with a Methodist preacher. In November he preaches his first sermon; wants to devote his life to the evangelization of the poor. In his spare time he still continues his interest in painting; visits the gallery in Hampton Court. At Christmas he visits his parents in Etten; worried about their son's condition, they prevent his return to London.

1877 JANUARY-APRIL: On his uncle's recommendation he gets a position as an assistant in a bookshop in Dordrecht. Leads a very lonely life, frequently visits the church and translates parts of the Bible into various languages; also draws.

MAY: Convinces his father of his religious vocation. Goes to Amsterdam in order to prepare himself for the entrance examination at the Theological Faculty. Lives with his Uncle Johannes, head of the municipal dockyards. Takes lessons in Latin, Greek and mathematics. Reads extensively, visits museums and draws. His studies prove extremely difficult and in the end he gives up.

1878 JULY: Returns home and then goes with his father to Brussels. There he intends to do a three-month course in preaching in order to become a lay preacher. As the course doesn't begin until August he goes back to Etten.

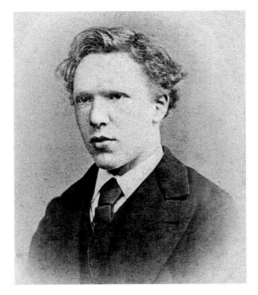

Vincent around 1872

AUGUST-OCTOBER: Attends the Evangelist school in Laeken, near Brussels, but is considered unsuitable for the lay preaching profession, so he returns to Etten.

DECEMBER: Tries to follow his vocation and travels to the Borinage, the Belgian coal-mining area close to the French border. Lives in extreme poverty, visits sick people and reads the Bible to the miners.

1879 JANUARY-JULY: Gets permission to work for six months as a lay preacher in Wasmes in the Borinage. Lives in a hut and sleeps on straw. Is deeply concerned about the living conditions of the miners, whom he supports with all his ability. His involvement in the plight of the poor irritates his superiors, who do not extend his contract under the pretext that his rhetorical talents are insufficient.

AUGUST: Walks to Brussels to get advice from vicar Pieterson. Shows him his sketches of the miners in the Borinage. Returns to the coal-

mining area of Cuesmes where he follows his vocation at his own discretion and without any payment. Stays there until July 1880. Supports the poor and sick people although he himself is living in extreme poverty. Reads a lot – Dickens, Hugo, Shakespeare – continues to draw and becomes more and more interested in painting. Experiences a period of deep personal crisis which is to mould his later life. Stops writing to his brother Theo for a while due to the latter's criticism of his choice of profession.

1880 JULY: Writes to Theo again, who supports him financially. Theo now works at Goupil's in Paris. Vincent describes his state of agonizing uncertainty.

AUGUST–SEPTEMBER: Avidly makes sketches of the miners' environment; Theo encourages him. Copies works by Millet.

OCTOBER: Goes to Brussels, where he studies anatomical and perspective drawing at the Academy of Art. Admires Millet and Daumier. In November he makes the acquaintance of the Dutch painter Rappard; they become friends. Stays in Brussels until April 1881.

1881 SPRING: Meets Theo in Etten to discuss his artistic future. Does not return to Brussels. Draws landscapes. Goes on hikes with Rappard, who visits him.

SUMMER: Sadly for him he falls in love with his cousin Kate (Kee) Vos-Stricker; she has just become a widow and is visiting his family in Etten with her child. Kee returns early to Amsterdam. Vincent travels to The Hague and visits the painter Mauve, whom he admires greatly.

AUTUMN: Goes to Amsterdam with the intention of marrying Kee, but she does not even receive him. To show the strength of his feelings, he holds his hand in the flame of a lamp while his parents watch.

NOVEMBER–DECEMBER: Visits Mauve in The Hague and there he paints, for the first time, still

Presbytery (centre) in Groot-Zundert, birthplace of Vincent and Theo van Gogh. Vincent was born in the room with a flag at the window.

View into the interior of The Hague branch office of the art dealer Goupil & Cie. Here Vincent was introduced to the art trade.

View of the vicarage in Nuenen

lifes in oils and watercolours. His relationship with his parents deteriorates mainly due to Vincent's refusal to give up Kee and because of his advocation of extreme religious views. He quarrels with his father at Christmas. Vincent refuses to accept money from his father and leaves Etten.

1882 JANUARY: Vincent moves to The Hague and lives in the same area as Mauve, who teaches him the techniques of painting and also lends him some money. Theo sends him 100 to 200 florins every month. His relationship with Mauve deteriorates because of Vincent's refusal to work from plaster models. Gets to know Clasina Maria Hoornik, known as Sien, a prostitute and an alcoholic. Sien is pregnant and Vincent takes care of her. She serves as his model.
MARCH: Severs ties with Mauve, whom he still admires. His relationships with the other painters become strained. Only Weissenbuch appreciates his work. Bases a lot of his drawings on nature; finds his models, except Sien, in the slums; his only commission comes from his uncle Cornelius, who orders twenty pen-and-ink drawings of the city.
JUNE: Is cured of gonorrhoea in the local hospital. His father and Tersteeg visit him. Wants to marry Sien in spite of the opposition of his family and friends. Takes her to Leiden where she can give birth to her child; looks for a flat for the future family.

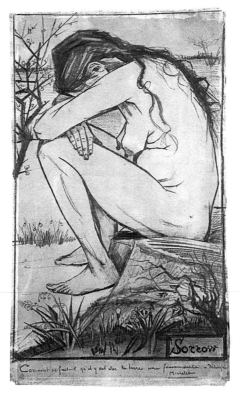

Vincent's lover Clasina Maria Hoornik sat as a model for this drawing "Sorrow". Black chalk, 44.5 x 27 cm (17½ x 10½ in.). The Hague, April 1882. Walsall Museum and Art Gallery, Walsall

SUMMER: Concerns himself with the various uses and techniques of colour, in order to prepare himself for his later paintings using oils. Theo gives him some money for painting material. Paints mainly landscapes (see p. 9). Father accepts a position as a vicar in Nuenen, where he moves with his family.
AUTUMN: Stays in The Hague until the summer of 1883. Paints landscapes and draws scenes from nature. In the winter he makes sketches and draws portraits; his models are ordinary people, inhabitants of old people's homes and Sien with the new-born child. Gets to know the painter Weele, with whom he paints in the dunes next spring. Begins to take an interest in lithography. Continues to read a lot, even journals like *Harper's Weekly* and *The Graphic*.

1883 SEPTEMBER–NOVEMBER: After discussions with Theo he makes the painful decision to separate from Sien with whom he has lived for a year. Goes alone to Drente, a province in the north. Travels by boat to Nieuw-Amsterdam; there he goes on long walks. The landscape with its dark peat bogs fascinates him as it has fascinated Liebermann and his friends Mauve, Rappard and Weele before him. Draws and paints the hard-working peasants of that region. Visits the old village of Zweeloo where Liebermann lived for a long time.
DECEMBER: Moves to Nuenen, the home of his parents. There he stays until November 1885. Paints about 200 pictures during these two years, which are characterized by a dark and earthy tonality. Besides Zola he reads theoretical texts on art by Delacroix and Fromentin and he is convinced of the close relationship between colour and music (Wagner); takes singing and piano lessons. His parents want to help Vincent; overlooking his eccentric clothing and strange behaviour, they allow him to make a studio in a side building adjoining the vicarage.

1884 JANUARY: His mother breaks a leg and has to stay in bed for a long time; Vincent takes loving care of her.
MAY: Moves his studio into the house of the Catholic sacristan. Rappard pays him a visit.
AUGUST: Both sets of parents object to his brief love-affair with Margot Begemann, a neighbour. Margot attempts suicide.
AUGUST–SEPTEMBER: Paints six decorative pictures for the dining-room of the goldsmith Hermans in Eindhoven.
OCTOBER: Rappard visits him in Nuenen.
OCTOBER–NOVEMBER: Gives some amateurs painting lessons in Eindhoven; together they go on walks and visit museums.
DECEMBER: In the winter he is busy sketching portraits; before this, peasants and weavers at work and landscapes were his main themes.

1885 On the 26th March his father Theodorus dies of a stroke. Vincent is heartbroken. After a quarrel with his sister Anna he moves into the studio in the house of the sacristan.

The Rue Lepic in Montmartre, Paris. In June 1886, Theo van Gogh moved into number 54 where he accommodated his brother, whom he allowed to make a studio there.

Vincent worked as a lay preacher in the Borinage, the coal-mining area on the Belgian-French border. The picture shows the No. 7 mine in Wasmes.

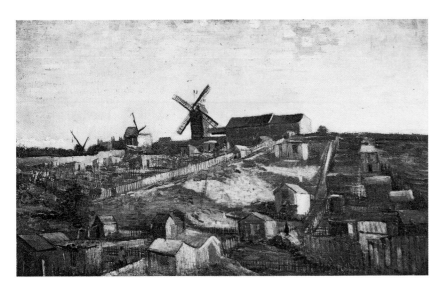

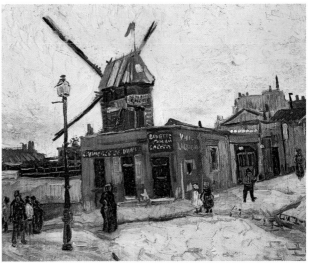

The Hill of Montmartre
Paris, autumn 1886
Oil on canvas, 36 x 61 cm (14 x 24 in.)
Kröller-Müller Museum, Otterlo

Moulin de la Galette
Paris, autumn 1886
Oil on canvas, 38.5 x 46 cm (15¼ x 18 in.)
Kröller-Müller Museum, Otterlo

APRIL–MAY Paints *The Potato Eaters* (p. 14), the main work of his Dutch period. Sends a lithograph of the picture to Rappard who criticizes it and in so doing precipitates the end of their friendship.

SEPTEMBER: The Catholic priest forbids the villagers to sit as models for him (since a peasant woman, whom he had drawn before, had become pregnant). Draws still lifes of potatoes and bird's nests.

OCTOBER: Travels with his friend Kerssemakers from Eindhoven to Amsterdam and visits the Rijksmuseum. Rembrandt and Hals fascinate him.

NOVEMBER: At the end of the month he moves to Antwerp where he stays until February 1886. Wants to get in touch with artists and tries to sell his pictures. Visits museums and is above all impressed by Rubens. While scouting through the city he discovers some Japanese woodcuts, which he buys.

1886 JANUARY: Enrols at the Ecole des Beaux-Arts; takes courses in painting and drawing. His disapproval of the academic method of teaching here leads to disagreements. But nevertheless he takes part in the entrance examination for the senior classes.

FEBRUARY: Is sick for a month due to malnutrition, overwork and heavy smoking. At the end of February he comes to Paris in order to take lessons from Cormon.

MARCH: Arrives in Paris and arranges a meeting with Theo at the Louvre. Theo, who runs a small gallery for Goupil at the Boulevard Montmartre, accommodates him. In the meantime the academy in Antwerp rejects his specimens and demotes him to the beginners' course.

APRIL–MAY: Studies in the studio of Cormon where he makes the acquaintance of Bernard, Russel and Toulouse-Lautrec. Theo also introduces him to Monet, Renoir, Sisley, Pissarro, Degas, Signac and Seurat. From now on the colours on his palette become considerably brighter, noticeable in his still lifes and flower paintings.

MAY: His mother leaves Nuenen. A second-hand dealer buys up all the pictures he left in the house, sells them off for ten centimes each and burns the unsold remainder.

JUNE: Moves with Theo to the Rue Lepic in Montmartre where he is allowed to establish a studio. Paints Paris city views in the style of the Pointillists.

WINTER: Makes friends with Gauguin, who comes from Pont-Aven to Paris. Due to Vincent's difficult character his relationship to Theo, who is suffering from a nervous disease, becomes more and more strained. Vincent writes to his sister and tells her that life with Theo is "almost unbearable".

1887 SPRING: Meets Bernard in Père Tanguy's paint shop. Both of them work in Asnières, on

Vincent (with his back to the camera) with his friend Emile Bernard on the banks of the Seine in Asnières, 1886

the banks of the Seine. In discussions with Bernard and Gauguin Vincent refuses to consider Impressionism as a final stage in the development of painting. Buys Japanese woodcuts in the "Bing" gallery. Frequently visits the Café de Tambourin on the Boulevard de Clichy; brief love-affair with the owner Agostina Segatori (see p. 21), a former model of Corot and Degas. There he exhibits together with Bernard, Gauguin and Toulouse-Lautrec and he decorates the walls with Japanese coloured woodcuts. This group is called "Peintres du Petit Boulevard" in contrast to the "Peintres du Grand Boulevard" (Monet, Sisley, Pissarro, Degas, Seurat), who exhibit in Theo's gallery.

SUMMER: Paints several pictures using the techniques of Pointillism.

1888 FEBRUARY: Vincent leaves Paris where he has painted more than 200 pictures during the last two years and goes to Arles. He is attracted by the bright light of the south and by the warmth of the colours. Presumably Toulouse-Lautrec has influenced this decision.

MARCH: Dreams of living together in an artists' commune which would eliminate all material needs. Paints many pictures with blooming flowers and trees which remind him of Japanese landscapes. On receiving the news of Mauve's death he dedicates a picture to his memory (see p. 35). At the Paris Salon des Artistes Indépendants three of his pictures are exhibited.

MAY: Rents for 15 francs a month the right wing, consisting of four rooms, of the "yellow house" on Place Lamartine; here he wants to realize his dream of an artists' commune. Until the flat is furnished he sleeps at the Café de Alcazar (see pp. 44/45) and takes his meals in the station restaurant of Madame Ginoux (p. 51). Paints the famous *Langlois Bridge at Arles* (p. 33).

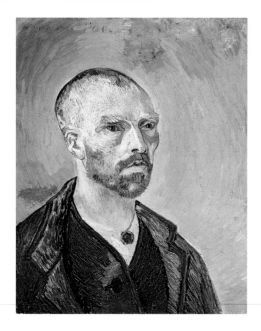

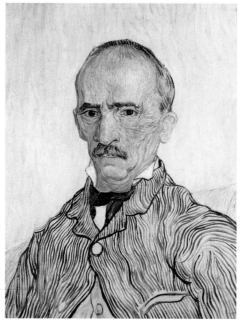

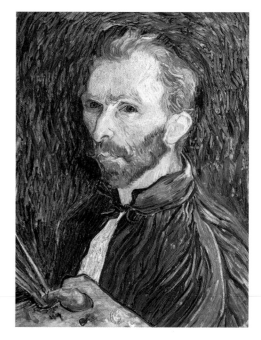

Self-portrait (Dedicated to Paul Gauguin)
Arles, September 1888
Oil on canvas, 62 x 52 cm (24½ x 20½ in.)
Fogg Art Museum, Harvard University,
Cambridge (Mass.)

***Portrait of Trabuc, an Attendant at
Saint-Paul Hospital***
Saint-Rémy, September 1889
Oil on canvas, 61 x 46 cm (24 x 18 in.)
Kunstmuseum Solothurn,
Dübi-Müller Foundation, Solothurn

Self-portrait
Saint-Rémy, late August 1889
Oil on canvas, 57.2 x 43.8 cm (22½ x 17¼ in.)
National Gallery of Art, Collection of Mr and
Mrs John Hay Whitney, Washington DC

JUNE: After a trip to Saintes-Marie-de-la-Mer he paints pictures with boats (p. 37). Gets to know the second lieutenant of the Zouaves, Milliet (p. 39), who takes painting lessons from him and accompanies Vincent on walks.
JULY: Many landscape paintings are made during his numerous outings to Montmajour near Arles (see p. 36). Inspired by reading Loti's *Madame Chrysanthème* he paints the portrait *La Mousmé, Sitting* (p.40).
AUGUST: Makes friends with the country postman Joseph Roulin, whose portrait he paints (pp. 42 and 43). Sends his brother Theo 35 pictures via the Zouave Milliet. Paints a series of sunflowers (see p. 30).
SEPTEMBER: More and more he paints out of doors at night. Whilst doing so he fixes candles to the brim of his hat and to the easel (see p. 47). Gets to know the Belgian poet and painter Boch and makes friends with him. Moves into the "yellow house".

The "Alcazar" in Arles, where Vincent painted his famous *Night Café* (p. 44–45).

OCTOBER: After Vincent's repeated requests Gauguin finally comes to Arles. The two live and work together.
DECEMBER: Visits the museum in Montpellier with Gauguin, where they see Courbet's painting *Bonjour, Monsieur Courbet*, which was Gauguin's inspiration for a later picture. Disputes arise between them, described later by Vincent as "exaggerated tensions". After living together for two months their relationship begins to deteriorate. According to Gauguin's report, Vincent attacks him with a razor blade on 23rd December. Gauguin spends the night in an inn. During this night Vincent suffers a fit of

The hotel and restaurant Carrel in Rue Cavalerie 30, Vincent's first lodgings in Arles

mental derangement and cuts off the lower part of his left ear. He wraps it in newspaper and takes it as a present to a prostitute called Rachel in a brothel. The next morning the police find him lying injured in his bed and take him to hospital. Gauguin leaves and informs Theo about his brother's condition. Immediately Theo comes to Arles. Epilepsy, dipsomania and schizophrenia are the presumed causes of his illness.

1889 JANUARY: From the hospital Vincent writes a letter to Theo (see p. 61) and tells him that he is feeling better; he adds some cordial words for Gauguin. On the 7th he moves into the "'yellow house". Writes reassuring letters to his mother and sister although he suffers from sleeplessness. Paints two self-portraits showing his bandaged ear (p. 59).
FEBRUARY: Because of sleeplessness and recurring hallucinations he has to go back into

"The yellow house" in Arles (see p. 48).
Vincent rented the right wing.

Van Gogh's room in the mental hospital Saint-Paul-de-Mausole in Saint-Rémy, with an iron bed and chair

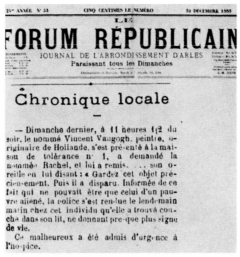

The *Forum Républicain* of 30th December, with the report on Vincent's cut ear

The Ravoux Inn in Auvers where Vincent lived in 1890

hospital; in between his hospital stays he constantly paints in the "yellow house".

MARCH: On account of a petition, instigated by the citizens of Arles, Vincent has to be brought back into hospital.

APRIL: Signac visits him; they are allowed to return to his house, which in the meantime has been closed by the police. Theo marries Johanna Bogner, the sister of a friend. Vincent paints again and sends Theo two boxes full of masterpieces.

MAY: Although he feels better he goes of his own accord into the mental hospital Saint-Paul-de-Mausole near Saint-Rémy-de-Provence. Theo pays for two rooms for him, one as a studio with a view of the garden. Is allowed to paint outdoors under the supervision of the ward attendant Poulet; paints mainly landscapes.

JUNE: At the end of the month he paints *Cypresses* (pp. 65, 67, 69, 70 and 71).

JULY: After a visit to Arles he suffers a severe attack whilst painting outdoors. Is unconscious for a time and his memory is impaired.

AUGUST–NOVEMBER: Continues to paint, but with interruptions. Copies Millet and Delacroix liberally. Writes to Theo and tells him that he wants to come back to the north. Sends six pictures to Brussels to be exhibited at the "Les XX" show.

DECEMBER: Sends Theo three parcels with pictures. During another attack he attempts to swallow paint.

Van Gogh's death chamber in the Ravoux Inn in Auvers

1890 JANUARY: Has an exhibition in Brussels. Toulouse-Lautrec challenges a painter who criticizes Vincent's pictures to a duel. First enthusiastic criticism in the *Mercure de France*. Writes to Theo telling him that he has never felt more at peace. On the 31st Theo's son is born and baptized Vincent Willem after his uncle and godfather.

FEBRUARY: Dedicates *Almond Blossom* (p. 76) to his nephew. Theo informs him that Anne Bach has bought his picture *Red Vineyard* for 400 francs in Brussels. Immediately afterwards he suffers another serious attack which forces him to rest for more than a month. Exhibits ten paintings at the Paris Salon des Artistes Indépendants.

MAY: After his latest crisis he visits Theo and his family in Paris. He then settles in Auvers-sur-Oise, near Paris. For the time being he lives in the Saint Aubin inn, then in the café owned by a couple by the name of Ravoux. Theo has chosen Auvers because Dr Gachet, an amateur painter and friend of the Impressionists, is living here and he agrees to take care of Vincent. Gachet admires Vincent's art and they become friends. In Auvers he paints more than eighty pictures.

JUNE: Spends a weekend at Gachet's house together with his brother's family.
Paints *The Church at Auvers* (p. 62).

JULY: Visits Theo in Paris where he also meets Toulouse-Lautrec. Due to Theo's professional worries and the ill-health of his son, Vincent soon returns to Auvers. Paints several pictures of a larger format showing fields under a thunderstorm sky (pp.86/87). On the 23rd he writes his last letter. On the afternoon of the 27th he goes out, comes home late and retires to

his room. Mr and Mrs Ravoux notice that he is suffering great pain. Vincent confesses that he has shot a bullet into his breast. Gachet dresses his wounds and informs Theo. On the 29th van Gogh sits the whole day in his bed smoking a pipe. He dies in the night and is buried at the cemetery of Auvers on the following day. Besides Theo and Gachet some friends from Paris, amongst them Bernard and Père Tanguy, attend the funeral.

1891 After Vincent's death Theo descends into depression. He dies on the 21st January in Utrecht. In 1914 his corpse is exhumed and buried next to Vincent's grave in Auvers.

The gravestones of Vincent and Theo at the cemetery in Auvers

Credits

The publisher would like to thank the following museums and archives for giving permission to reproduce the works in this book. Unless stated otherwise, the copyright for the illustrated works is owned by the collections and institutions listed in the picture captions, or by the archives of the publishing house.

Van Gogh Museum/Vincent van Gogh Foundation, Amsterdam 2, 9, 10, 12, 14, 15, 21, 22, 25, 28, 36, 37, 49, 57, 68, 76, 86–87; akg-images, Berlin: 17, 42, 69, 85, 88, 90 middle, 91 top, 91 bottom left, 94 bottom right; Rheinisches Bildarchiv, Cologne 33; Bridgeman Art Library, London: 29, 39, 40, 43, 53, 59, 66, 67, 74, 83, 84; National Gallery Picture Library, London: 57; The Museum of Modern Art, New York/Scala, Florence: 71; Collection Kröller-Müller Museum, Otterlo: 8, 13, 24, 26, 32, 35, 47, 54, 70, 78, 8l; RMN, Paris: 19, 73 (Blot), 77 (Jean), 62, 75 (Lewandowski); Artothek, Weilheim: 64,30, 60 (Blauel), 44–45 (Hinz), 5l, 52 (Martin); Collection Oskar Reinhart "Am Römerholz", Winterthur: 18, 61; Künsthaus, Zurich: 11, 56, 89; Collection E. G. Bührle Foundation, Zurich: 6, 55.